HIDDEN HISTORY

HISTORY

of

MARTHA'S VINEYARD

Thomas Dresser

THE
History
PRESS

Published by The History Press
Charleston, SC
www.historypress.net

Copyright © 2017 by Thomas Dresser
All rights reserved

First published 2017

ISBN 9781467135955

Library of Congress Control Number: 2016950697

To the memory of Susan Gamble, whose cheerful manner and indomitable spirit were an inspiration to all who knew her. May she rest in peace, among the flowers.

CONTENTS

FOREWORD

There are ten thousand years of stories on Martha's Vineyard, and yet we know so few of them.

We know the legend of Moshup, who strode across Noepe like a giant when the world was new and pulled whales from the sea by their tails to feed his people. We know that Bartholomew Gosnold sailed here in the name of his dying virgin queen, that he sought gold but found wild grapes and sassafras instead and that he left behind the name of a woman who would never see (let alone set foot on) the island that has borne it ever since. We know the nineteenth-century Methodists' and Baptists' revival meetings begat—to their surprise and, perhaps, dismay—a thriving secular resort where bathhouses lined the beaches and dance bands played late into the summer night. And we know—even if we do not know their names—the whalers, the Edgartown masters, Gay Head harpooners and Tisbury deckhands who chased their prey to the far corners of the world and retired (if they were lucky) to the shops and farms and fine new homes that whaling money built.

We tell those stories to one another—in newspapers and town meetings, with wall-spanning murals and bronze plaques by the roadside—as part of our ongoing conversation about who we are as a community. We tell them to visitors—in guidebooks, on bus tours and in posters on the ferries—as we try to convey a glimpse of what the Vineyard is like. We tell them to our children and grandchildren, so that they might one day do the same, beginning with a ritual incantation that is probably as old as language itself: "Now, when I was your age..." We tell them to the world—in books and articles, music and

movies, posters and plays—so that they might be woven into the vast, never-finished tapestry of stories that is the history of humankind.

We tell those stories—keep and cherish and hold them in common—but even as we do, we realize (if we are honest with ourselves) that they are only a tiny fraction of the stories that have unfolded across ten thousand years, on this one-hundred-square-mile triangle of wind- and wave-swept land. Every marker in every island graveyard, every oak timber peeking from the sand after a storm and every stone wall or tumbled foundation hidden in the deep woods points to a new story, waiting to be told. Every packet of letters or box of long-forgotten keepsakes uncovered in a forgotten dresser drawer or dusty attic trunk can be a treasure-trove of new stories or new chapters of familiar ones. The Martha's Vineyard Museum holds thousands of objects and tens of thousands of documents, images and maps—the tangible traces of countless unrecorded and half-remembered stories, waiting to be told.

Discovering new stories, adding new dimensions to old ones and sharing the results with others are among the great joys of being a historian. Some of us share our discoveries in museum galleries, some behind microphones, some on movie and television screens and some in conversations across library desks. Tom Dresser shares his—in words and carefully chosen images—in books like this one. There are ten thousand years of stories on Martha's Vineyard, and Tom knows more of them than almost anyone you're likely meet, in person or in print. So turn the page, settle in and let him tell you some.

A. BOWDOIN VAN RIPER
Reference librarian, Martha's Vineyard Museum
Editor, Dukes County Intelligencer
Former adjunct professor of history, Southern Polytechnic State University

PREFACE

An intriguing aspect of living and writing on Martha's Vineyard is the fount of endless avenues of historical research to explore. Martha's Vineyard offers a vista of the grand historical panorama; it truly is a microcosm of the road Americans have traveled. The island presents a panoply of cultural contrast, a diversity of customs and standards comparable to those writ large across our country.

Hidden History of Martha's Vineyard explores five prime topics of historical relevance that share comparative aspects "over in America," as Vineyarders speak of the mainland. People who live on Martha's Vineyard realize that life on the Vineyard mirrors what happens on the mainland, with a slight twist. We like to say, "It's an island thing" to explain or justify why and how life on the Vineyard is a little bit different from life "over in America."

An exploration of the derivation of names across the Vineyard, from towns and places of interest to streets, incorporates our Native American past, our colonial heritage and our sense of self.

The Underground Railroad was a small but integral aspect to the abolition of slavery. Escape routes wove across the North, guiding fugitive slaves to freedom. Slavery was an American dilemma, and the Vineyard played a role in that drama.

Like any seaside community, the Vineyard, as an island, has been susceptible to disasters at sea. Shipwrecks off the Vineyard have been numerous, dramatic and memorable.

Buildings offer a place to play and pray, read and sleep, gather and perform, as well as protect and promote us. Structures in the six Vineyard towns secrete histories and mysteries worth exploring. Many buildings with stories concealed in their past are prominent and public.

Finally, we step into Vineyard graveyards, similar to rural settings across New England. Family names repeat, indicating generations who remained in the same area. Native American burial grounds are unnamed and protected, preserving the spirits of the past. Grand monuments share the pride of our forebears while worn gravestones mark the ravishes and weathering of time.

Feel free to dabble in this *Hidden History of Martha's Vineyard*. Consider the present as we uncover the past. Weave historical relevance into what's happening now, for the past improves our grasp of the present.

This book can be read straight through, though it might be fun to dart from one topic to another. The theme is historical relevance; it is neither sequential nor plot-driven. Read what you want to enjoy first; savor the rest on a revisit.

Acknowledgements

It takes a village to raise a child; it takes a community to write a book. My gratitude to those who assisted in my efforts—and there were many—is sincere.

Perusing the microfiche files of the *Vineyard Gazette* in the Vineyard Haven Library was an enjoyable task. Hilary Wall at the *Vineyard Gazette* provided assistance on locating specific archival information. Charlie Kernick permitted reprinting of images from his Martha's Vineyard Antique Photos collection. Bow Van Ryper and Bonnie Stacey of the Martha's Vineyard Museum assisted with images. And Connie Sanborn gave me her trove of old photographs. To you all, I extend my appreciation.

Personal conversations, e-mails and interviews added to the project. John Alley, Arne Carr, Warren Doty, John Flender, Herb Foster, Susan Goldstein, Doug Hakey, Chris Hugo, Ann Lees, James Lengyel, Sam Low, Adam Moore, Jimmy Morgan, MJ Bruder Munafo, Casey Reagan, Alison Shaw, Michael West and Barney Zeitz shared freely of their time and expertise.

The History Press rocks. Ed Mack did not skip a beat when Joyce and I paid a surprise visit to THP headquarters on our road trip south in early 2016. Graciously, he showed us around the Arcadia/History Press facilities. Copy editor Julia Turner was a pleasure to work with. Katie Parry and Dani McGrath once again were there to get the job done. Brittain Phillips offered his support. It has been a good run.

ACKNOWLEDGEMENTS

And most of all, to my wife, Joyce, I owe unsurpassed debt for her unending support and encouragement on this venture. She also took the majority of fine photographs for the book, as well as completed timely edits of the entire manuscript. My gracious thanks and love.

VINEYARD NOMENCLATURE

The derivation of the names of various Vineyard venues is fascinating. The island itself, the towns, streets and community sites, all contribute to the panoply of intriguing names. While people are well aware of the name of a given town, not everyone knows the backstory; that's its hidden history.

When Captain Bartholomew Gosnold sailed his ship *Concord* along Cape Cod in 1602, he observed grapes growing in abundance on an island shore. What a good place for a vineyard, he thought. (That was 350 years before Chicama Vineyards began, had a nearly forty-year run and folded in 2008.) Gosnold started a little settlement on a nearby island, Cuttyhunk. He and his crew constructed a fort, planted crops and harvested sassafras. (Sassafras was a cash crop for Europeans, brewed as a tea to ease the pain of gout and combat syphilis.) Gosnold and his men lacked sufficient supplies to remain on Cuttyhunk, so after six weeks, they returned to England.

Gosnold named the larger island Martha's Vineyard in honor of his mother-in-law, Martha Golden, who financed his expedition. Gosnold's wife was also named Martha, as were two of his daughters. The first Martha died as an infant; another daughter was named Martha as well. An apocryphal line about a third daughter, Nancy, claims that when Gosnold discovered another island farther east, Nan took it (Nantucket). The Elizabeth Islands, on the western side of Vineyard Sound, were named for another Gosnold daughter, Elizabeth, not, as generally assumed, the reigning queen of England.

Noepe

Wampanoag, the local tribe of Native Americans, means "easterners" or "people of the dawn." When the sun rises, it first strikes the people of the East, the people of Martha's Vineyard, the Wampanoag.

Native Americans lived here even before the island became an island. When the oceans rose about 3000 BC, the high land of the Vineyard was surrounded by water. Native Americans called it Noepe, which translates to "land amid the waters." The Wampanoag gathered fish and shellfish from the nearby waters.

Native American names predominate on the Vineyard. "The great majority of these [Vineyard place names] are of Indian derivation. Altered in their spelling until they are not recognizable in their original form or pronunciation, abbreviated and clipped short at both stem and stern, yet these old Algonquin place names survive."[1] Vineyarders treasure the past.

At the western end of the island is the fishing village Menemsha. The name referred to the view of the harbor from nearby Peaked or Prospect Hill.[2] According to historian Charles Banks, "The name originally did not belong to the creek or the pond, but probably indicated a standing tree or pole placed on one of the hills near the creek, or it may have been the name of the locality itself, 'as seen from afar.'"

Cape Higgon, off North Road in Chilmark, evolved from the Wampanoag word Keephikkon, which means "fenced enclosure."

The great tidal pond Sengekontaket, behind State Beach, is quite shallow, making it ideal for shell fishermen to wade in for their catch. People in the Wampanoag settlement on the shores feasted on shellfish.

Squibnocket Pond, near the Chilmark-Aquinnah town line, is the largest freshwater pond on the Vineyard. It was once an arm of the ocean, an inland harbor of salt water where the Wampanoag gathered shellfish, as evidenced by middens of shells along the shoreline, dating back seven thousand years. Squibnocket means "where the red ground nut grows." Native Americans relished this red lily, with long, stem-like roots, akin to nuts.

Today, Squibnocket Pond is fresh water. A stream leads to Menemsha Pond, which affords herring passage for their annual rite to spawn. They swim up through a huge pipe under State Road, migrating from salt water to fresh.

The Wampanoag fished at Quansoo, once known as Quannaimes, where they caught "the long fish," or eel. Today, Quansoo is a quiet area, south of Nab's Corner, on South Road in Chilmark, a peninsula preserved by two conservation organizations, Sheriff's Meadow and the Land Bank.

Among the chain of Elizabeth Islands are Naushon, which means "middle"; Penakese; Nashawena; and Uncatena. All bear Wampanoag names. Cuttyhunk, where Gosnold temporarily settled, means "lies out in the sea."

At the eastern end of Noepe lies Chappaquiddick, or "separated island." This separation fluctuates, as the long sandbar of Norton Point at times connects Chappy to Edgartown proper, creating the basin of Edgartown Harbor. Other times, the point is breached, which allows Edgartown Harbor to open and the currents to wash through the break, creating challenges for the Chappy ferry. Pocha, similar to Poucha Pond, means "breaking in," which refers to a beach opening.

Tashmoo, in Vineyard Haven, once a freshwater pond, is now an arm of the ocean. Known as "the great spring" in the Wampanoag language, it was a settlement with access for fishing and fresh water. Nearby archaeological digs have uncovered charred fire pits and bones of white-tail deer, evidence of a Wampanoag settlement.

Sepiessa is a Land Bank property off New Lane in West Tisbury by Tisbury Great Pond. Of its derivation, Michael West, who writes under Sepiessa Press, quoted Charles Banks, from 1911: "The modern abbreviation of the neck is 'Sissa.' John Manter sold land on Tississa, in the Point called Sepiessa, alias Manter's Point."[3] West added, "I would guess that 'Sep' may then refer to something 'extended or stretched out.' Putting this all together, I say that Sep + iessa = stretched out or extended neck of land."

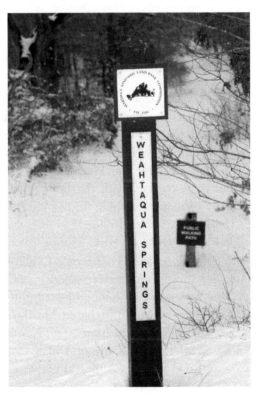

Weahtaqua Springs Preserve is a thirty-five-acre property, owned by the Martha's Vineyard Land Bank in Oak Bluffs, nestled by the roundabout near the center of the island. *Photo by Joyce Dresser.*

Weahtaqua (wee-uh-TOCK-wuh) "earned its name from a Wampanoag word meaning head of the Lagoon, which it overlooks. The land sits atop myriad springs which flow into nearby Stepping Stones Brook. A beech grove is emerging in the forest, which is bedecked with reindeer lichen and bearberry."[4]

At the most southeasterly corner of the Vineyard, along South Beach, a romantic Native American legend enlivens the story of Katama, the Wampanoag word for "crab fishing place." An Indian maiden, Katama, fell in love with Mattakessett, son of the sachem in a nearby village. Because they knew they could not marry, they swam out to sea. The Spirit of the Sea, Paumpagussit, welcomed them beneath the light of Nanepaushat, the moon. The spirits of Katama and Mattakessett live on as dolphins, frolicking in the waters off Katama.

MARTHA'S VINEYARD

Martha's Vineyard was settled in 1642 by Thomas Mayhew, an Englishman who bought the island to convert the Native Americans to Christianity. Along with his son, Thomas Jr., he set about his task, instituting English laws and customs, as well as the fervent Calvinist goal of creating a Christian community among the Wampanoag. Mayhew preached with his Bible, rather than coerced with the bullet, and succeeded in taking control of Martha's Vineyard without firing a gun.

In the mid- to late 1600s (1664–80), the colony of New Amsterdam was ceded to the Duke of York. The people of New Amsterdam curried favor with the duke, destined to become England's King James II (1685–88). New Amsterdam was renamed New York in his honor. Royal names were assigned to New York counties: Kings, Queens and Dutchess.

The Duke of York purchased Martha's Vineyard for £3,500. Martha's Vineyard, the Elizabeth Islands and Nantucket became Dukes County. The name evolved into County of Dukes County. Dukes County Avenue and County Road in Oak Bluffs and Old County Road in West Tisbury honor the Duke of York. Kings Highway follows suit.

Great James Pond, by Lambert's Cove Beach, was named for the Duke of York. In 1700, it was called Pond Royall. Once there was discussion about opening the pond to the ocean to create a harbor for West Tisbury, but the plan was defeated.

When James, Duke of York, assumed ownership of Dukes County, Thomas Mayhew petitioned for the political, economic and judicial control of the community. The Duke granted Mayhew his wish. Thus, Mayhew assumed the title of governor, although he was neither elected nor appointed to the position.

TOWN NOMENCLATURE

A key name change occurred in the seventeenth century. Edgartown was known as Nunnepog, or "freshwater place." Mayhew called it Great Harbour, and it was once known locally as Old Town. In 1664, the town was renamed to honor the Duke of York. Initially, it was to be Jamestown, but there already was a Jamestown in the colony of Virginia. Hence, it was decided to recognize the son of James, Duke of York, who was expected to grow up to be king himself. James had four sons. One of them, little Edgar, was two years old when the town was named for him in 1669. He died at the age of four in 1671, so Edgar Towne, now Edgartown, honored the

In 1642, Thomas Mayhew alighted on the shores of what they called Great Harbour, now known as Edgartown. *Photo by Joyce Dresser.*

young prince who never grew up to be king. This is the only Edgartown in the world.

Three Vineyard towns took names from England. Tisbury was named for the English town of Tisbury, Wiltshire, where Thomas Mayhew was born in 1593. Author/historian Charles Banks visited Old Tisbury England. He found in William the Conqueror's *DoomsDay Book* the town was spelled Tisseburie. Banks wrote, "Tisbury is situated in a beautiful garden spot, a rolling country, the South Downs of England, noted for the special sheep raised in that section. It is probable that the early practice of raising sheep on our island was brought here through Governor Mayhew."[5]

Tisbury Harbor was called Holmes Hole. In the last century and a half, it has become known as Vineyard Haven, the popular appellation for the town as a whole.

Chilmark also has English ancestry. In England, Chilmark was adjacent to the ancestral home of Thomas Mayhew, near Salisbury. On the Vineyard, Josiah, son of Miles Standish of Plymouth Plantation, first settled Chilmark in the 1660s. The town was incorporated in 1694 when it separated from Tisbury.

For two centuries, the Vineyard was made up of three sprawling towns: Edgartown, Tisbury and Chilmark. It was not until the late nineteenth century that three more towns came into existence.

West Tisbury, the second Vineyard settlement, was known as New Town. It was the southern section of Tisbury and separated in 1892. There is a point where four towns intersect, known as Four Town Bound. A marker for the juncture is placed close to the State Forest, near the Land Bank's Little Duarte's Pond Preserve on a pathway running south from Weahtaqua Springs Preserve.

The two remaining Vineyard towns, Oak Bluffs and Aquinnah, broke from their parent towns and underwent name changes as well.

Gay Head split from Chilmark in 1870 when a separate community was created for the Wampanoag tribe. British sailors had named the Gay Headland for its brightly colored clay cliffs. For decades, the community struggled to survive because it was so far from the rest of the island. State Road did not extend to Gay Head until the mid-1800s. Electricity did not reach Gay Head until President Truman learned this tiny hamlet was the last town in Massachusetts without electricity. Then the Gay Head lighthouse was electrified, and the town entered the twentieth century, in 1951.

In 1987, the Wampanoag tribe signed a deal with the federal government to reclaim its land, which had been taken in 1871 in a

convoluted effort to grant voting rights by taking tribal land. When the land was returned, a century later, Carl Widdiss, a member of the tribe, sought to change the name of the town. After a decade of red tape, the Massachusetts state legislature granted the name change from Gay Head to Aquinnah, or "little town under the hill."

Oak Bluffs was originally part of Edgartown. In 1880, the community separated from Edgartown and formed its own town, Cottage City, named for the gingerbread cottages in Wesleyan Grove. Thirty years later, the name was changed to acknowledge oak trees and impressive bluffs on the northeast shoreline. Now we have Oak Bluffs, although many tourists call the town Oaks Bluff.

And so all the towns are properly named.

Of the 351 towns and cities in Massachusetts, 3 changed their name in the twentieth century. Oak Bluffs replaced Cottage City in 1907, and Aquinnah replaced Gay Head in 1997. The third town was Manchester, which segued into Manchester-by-the-Sea in 1989.

ICONIC ISLAND SITES

Beetlebung Corner has been known as such for three centuries. The name first crops up in a 1729 deed that refers to the Beetle Bound Tree, a local boundary marker. "Hornbeam wood was used then in the manufacture of beetles for loosening the bungs of casks and hogsheads," according to Charles Banks.[6] Other names for the Beetlebung tree are black oak, tupelo or hornbeam.

Deep Bottom, along the Edgartown–West Tisbury Road, was named for the frost bottom, the lowest and coldest part of the island. The frost bottom was formed by the runoff from glaciers that settled across the landscape some ten thousand years ago. As the glaciers melted, water ran off, forming gullies in the outwash plain that are still visible along the West Tisbury Road.

Fulling Mill Brook in Chilmark was mentioned in a deed dated 1694. A fulling mill protected wool from shrinking. The brook originates in a swamp off Middle Road and empties into Chilmark Pond. It was the first property purchased and preserved by the Martha's Vineyard Land Bank in 1986.

Lambert's Cove Road was named for Jonathan Lambert, who settled in the area in 1694 with his family. He was the progenitor of the deaf community of Chilmark that lasted from the 1700s until 1950.

The Manor of Tisbury was another Thomas Mayhew land grab.[7] "Recollections of Tisbury [England] with its manor aroused in him a desire to become the head of a like social institution."[8] Mayhew and his grandson Matthew requested the manor from the governor of New York in 1671. The manor included land in Chilmark, as well as land on the Elizabeth Islands. Thomas and Matthew Mayhew were Lords of the Manor of Tisbury. They instituted English aristocracy and mimicked their forbears by raising sheep.

The Middle Line, along Middle Road, was a division Matthew Mayhew created to separate the Wampanoag from the white settlers. The line ran from Waskosim's Rock to Menemsha Pond (spelled Monamesha in the original deed). The Mayhews purchased land to the south and east for the white settlers; land to the north and west went to the Wampanoag.

Nab's Corner, on State Road by the town line, was named in the eighteenth century for a woman named Abigail Dunham, who "achieved considerable notoriety during her life,"[9] according to Charles Banks.

South Beach is the eponymous shoreline off Katama. During the Second World War, the public was denied access because practice bombing flights were conducted from the air and practice landings were enacted on the beach. An experimental pipe was developed off shore that was intended to lie under the English Channel to fuel the Allied invasion of Normandy. The British-designed piping coiled like a garden hose, which was better than the Vineyard plan to weld mile-long sections of pipe. Today, signs note live munitions may still be buried along the shoreline.

East Chop and West Chop on the Vineyard's northern pinnacle bear various attributions. East and west separate the two chops, or jaws. These pinchers protect the entrance to Vineyard Haven Harbor. Swirling currents off the peninsulas create choppy waters. The lighthouses on East and West Chop flash green on the left and red on the right sides of the harbor, as in "red, right, returning to harbor."

On East Chop the Claghorn Tavern, circa 1730, provided a comfortable haven for weary sailors. Innkeeper Sally Claghorn recalled that Commodore John Paul Jones stayed there prior to the Revolutionary War.

Eastville was a settlement along East Chop, near today's Martha's Vineyard Hospital. Pirates often tricked captains into running their ships ashore, allowing the pirates to loot the beached vessels. Mooncussers was the name for these pirates; they would hang a lantern on a pole so an unsuspecting captain would guide his ship by the "moon" and then run aground. The full moon revealed the pirates' deceit; hence they cursed the moon. This was the Barbary Coast of the Vineyard, dangerous for off-islanders.

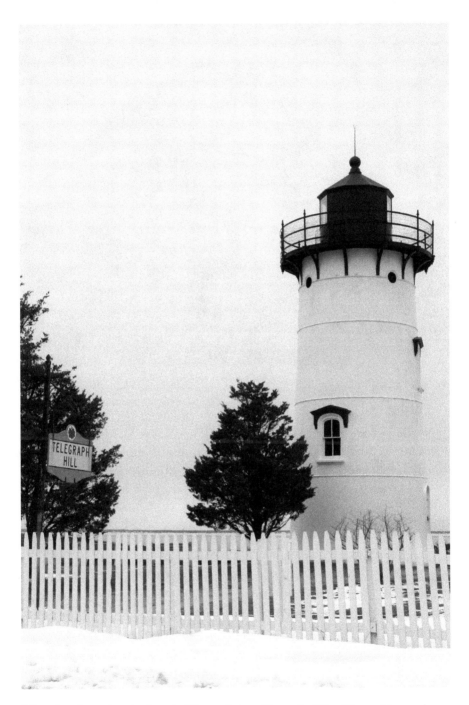

When the telegraph arrived on the Vineyard, the cable reached East Chop, nicknamed Telegraph Hill. *Photo by Joyce Dresser.*

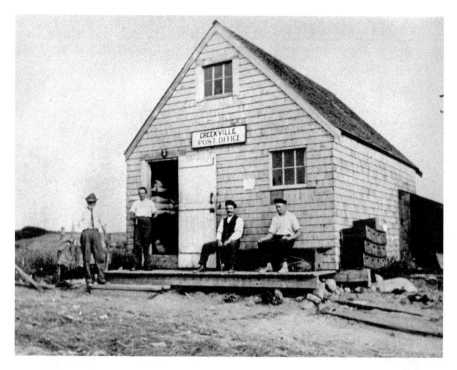

The tiny village of Creekville boasted its own post office in the early twentieth century. Creekville is now known as Menemsha. *Courtesy of the Connie Sanborn collection.*

North Tisbury once had its own post office, in the building now called Bananas, by the historic oak at the intersection of State and North Roads. North Tisbury as a settlement morphed into Middletown, a community in the middle of the island, still part of West Tisbury. It expanded along State Road to include the shopping center by Up Island Cronig's, where the post office relocated. That part of town is now the business section of West Tisbury.

Ocean Heights, on the Edgartown–Vineyard Haven Road, names a development on the south shore of Sengekontaket Pond. The numbered streets, from Third to Twelfth Streets North, are known as Ocean Heights. The land is a mere thirteen feet above sea level.

An icon from the colonial era has been replaced to stand tall again. The fabled Liberty Pole, on Main Street in Vineyard Haven, across from Owen Park, was first erected in the 1700s. The pole was nearly taken by British sailors of the British man-of-war *Unicorn* to replace a damaged spar in the spring of 1778. In stubborn defiance, three brave young Vineyard women blew up the pole rather than turn it over to the Brits.[10] (One of the three

Liberty Pole heroines, Polly Daggett Hillman, worked at the Claghorn Tavern, in East Chop, according to historian Charles Banks.)

Before the Revolution, the British depended on New England trees for their strong, tall masts. "After Lexington and Concord, New England cut off the shipment of tall pines to England, with the result that the British Navy was hampered by old, easily broken masts throughout the War for Independence.... At the end, trees helped to win the very war that they had inspired."[11]

NINETEENTH-CENTURY NAMES

When considering place names of the nineteenth century, we are reminded that "boys will be boys" regardless of the place or the century.

In the 1850s, in Edgartown, the *Vineyard Gazette* admonished the loose goats and young men riding their horses too fast through town. "Highly reprehensible," scolded the newspaper.[12] And three years later, it was fears of the boys swimming the quarter mile across Edgartown Harbor to Chappaquiddick, against the strong tides.[13]

Then there was a party boat, the *Eagle's Wing*, that steamed all the way out to Gay Head and back to Tarpaulin Cove. The *Gazette* worried about "the annoyance caused by a few young bloods whose extreme exuberance of spirits caused them to overstep, in some instance, the bounds of propriety." The *Gazette* went on to warn of "fast boys" who broke the Sabbath, drank and gambled.[14]

And the *Gazette* enjoyed a joke, as well: "Why are husbands like dough? Women knead them."[15]

John Wesley founded Methodism, so it is appropriate that the Methodist Campground in Oak Bluffs, first settled in 1835, assumed the appellation of Wesleyan Grove. The campground flourished as a religious retreat each summer. Congregants raised canvas tents on platforms, gathered beneath great oak trees and listened to their pastors preach.

The number of tents increased each year for the first two decades. By the mid-1850s, more than 250 tents were raised each summer. Methodists replaced their tents with four-room wooden cottages, of American Carpenter Gothic design, between 1855 and 1875. Wesleyan Grove covers some thirty-three acres and boasted five hundred cottages at its peak. Today, three hundred gingerbread cottages are extant, with about 10 percent used year-round.

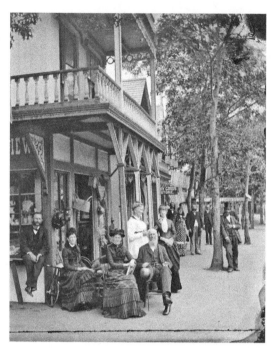

Circuit Avenue is the primary route through Oak Bluffs, with shops and restaurants and a parade of people of all shapes, sizes and description. *Photo of Mrs. Woodward's group on Circuit Avenue from the Basil Welch collection, courtesy of the Martha's Vineyard Museum.*

The central route through Oak Bluffs is Circuit Avenue, named for itinerant ministers on their circuit. Cars and people trace the circuit, turn up Kennebec Avenue and circle around the Flying Horses again and again to see and be seen.

In West Tisbury, one of its more quintessential New England streets once had a less appealing name. Years ago, farmers drove wagons of manure down this roadway to empty them out of the town. Over the years, the street became gentrified as whaling captains bought houses and furnished them with pianos to amuse their wives and daughters. As manure-laden wagons lumbered past houses from which the melodic sounds of music emanated, one farmer muttered to another, "We should call this Music Street, instead of Cow Turd Lane." Today, Music Street runs out of town between the Congregational church and town hall to the rural backwoods.

Adjacent to Music Street is the three-story West Tisbury town hall, once the local public school. Earlier, it was the home of the Dukes County Academy, which operated from 1837 to 1940. Teacher Leavitt Thaxter earned $12.50 a week. Tuition for island students was $2.50 per term, with three fourteen-week terms. Off-island students paid $5.00 per term.

The first Martha's Vineyard Agricultural Society Fair was held at the Dukes County Academy in 1858. Leavitt Thaxter won prizes for his apples, beets, corn, squash and turnips.[16]

The West Tisbury Free Public Library Association opened in 1893. It purchased the small building on Music Street that had been the academy study hall and dormitory. The library operated out of that building

until 1968, when it was relocated. The library was rebuilt and expanded in 2014.

Owen Park was named for William Barry Owen, (1860–1914), a gentleman from Vineyard Haven who managed London's Gramophone Company. Owen purchased the painting of a dog, Nipper, cocking his head at the sound from a Victrola. The image of Nipper, entitled *His Master's Voice*, became the iconic trademark of RCA Victor. Owen's son, Knight Owen (1893–1935), was shot to death on the shores of Lake Tashmoo in a spat over a woman.

Cow Bay, in Edgartown by Bend-in-the-Road Beach (no explanation necessary), earned its name from a dairy that operated there for decades. Yes, milk cows were common across the island, years ago.

In Oak Bluffs, below Ocean Park, is Pay Beach. Why? Well, you had to pay a nickel a day to use the bathhouse that extended along the shore. In recalling his many years swimming in the waters off Oak Bluffs, longtime campground summer resident Albion Hart recalled hanging his woolen bathing suit in the bathhouse to dry, only to find it still damp the next day. Swimming in the early twentieth century was more of a procedure than it is today. Pay Beach, with its bathhouse and observation tower in the shadow of the steamship dock, was popular well into the 1930s, when Oak Bluffs flourished as a nascent tourist community.

African Americans were not welcome at Pay Beach; they swam farther down the shoreline at the Inkwell. The Inkwell was initially a derogatory term but later gained sophistication as a place of peace and refuge. The name has two plausible derivations. Staff from the *Amsterdam News*, a Harlem newspaper, summered in Oak Bluffs, and the name was associated with their profession. The newspaper owned a house by the beach, on Waban/Dennis Alley Park. Another derivation is that the swirling black waters between the breakwaters are reminiscent of an ink well.

A popular summer group, the Polar Bears, swim at the Inkwell. The Polar Bears are primarily summer people; they congregate at the Inkwell in the mornings, all summer long. These meetings involve swimming and exercise, but they are also social gatherings, religious experiences and a means to embrace and foster friendship. Members share their status based on how many years they have frequented the Inkwell.

TWENTIETH-CENTURY NAMES

Both Vineyard Haven and Oak Bluffs celebrate a section of their respective towns as Chicken Alley. In Vineyard Haven, the alley runs off Five Corners, out toward Hines Point. In Oak Bluffs, it is along Vineyard Avenue, from Dukes County Avenue to County Road. The name Chicken Alley originated from numerous Portuguese families who kept chickens, a staple of their diet. Chickens provided eggs and meat. For immigrant families, raising chickens made sense. And living among like-minded people solidified the image. Chicken Alley is the nickname of the Martha's Vineyard Community Services Thrift Shop on Lagoon Pond Road in Vineyard Haven.

In the 1950s, as tourism expanded across Martha's Vineyard, it was decided to build a road along the peninsula of Gay Head to give tourists, especially those in tour buses, a chance to see more of the sea. The challenge was that tons of beach sand had to be hauled away before the roadway could be created. Moshup Trail opened for traffic in 1958. Moshup is the legendary ancestor of the Wampanoag.

Martha's Vineyard Land Bank makes an effort to utilize Native American names to designate new properties. A glance at its nearly seventy properties shows that one-third bear Native American names. I consulted with James Lengyel, executive director, regarding naming Land Bank properties. He said, "Ah, one of my favorite topics: toponymy."

He explained the naming process: "We tend first to scout around to see if there is a Wampanoag toponym for the area—these names have the double benefit of being both historic and euphonious. English historical names are also reviewed, as are geographical names. That said, it's usually rather easy to name a property: people have instincts about what is right and fitting."

Lengyel added, "The namer is the town advisory board, with commission concurrence."

I asked which names he likes. "My favorites are the Qs: Quammox and Quansoo (which, glacially speaking, just happen to exist in the same geographical location, although one is in Chilmark and the other on Chappaquiddick).

Vive toponymy!"

Street Names

One of the more historic Island roads is Dr. Fisher's Road, created in the mid-1800s. It ran from Edgartown across to the farm fields of West Tisbury. Dr. Fisher's Road is still viable but not for vehicles. Much of it is overgrown, but it can be walked by the erstwhile hiker. The road appears on some maps, but it is not well traveled. Dr. Fisher's Road has faded into the annals of history, the remnant of a bygone era.

Two early surveyors, Otis and Bassett, drew the line that separated Chilmark from Tisbury in 1694. When Jay Schofield Sr. worked for Schofield Brothers, a team of surveyors, he named the street off Old County Road for Otis and Bassett. The sign maker shortened it to Otis Bassett Road, without the benefit of an *and*.

Red Coat Hill Road, also in West Tisbury, recalls the Revolutionary War. Major General Charles Grey led a fleet of British warships into Holmes Hole Harbor. He had already conducted raids in Fairhaven and New Bedford and intended to do the same on Nantucket, but unfavorable winds forced

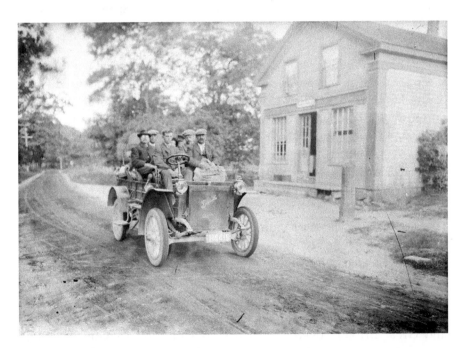

Passengers in this Buick enjoyed cruising through North Tisbury, passing what was once the post office, then the Red Cat and now Bananas. *Courtesy of the Basil Welch collection of the Martha's Vineyard Museum.*

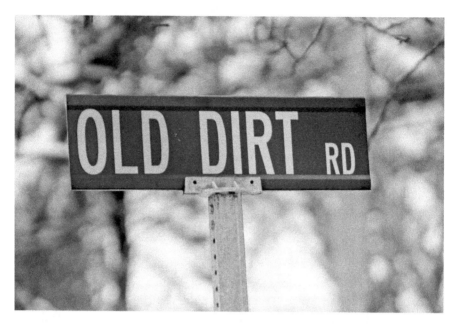

Unusual street names bespeak the character of local residents: Easy Street, Line Drive and Drive Way. Old Dirt Road is in Oak Bluffs. *Photo by Joyce Dresser.*

him to remain in Vineyard waters. Grey's Raid netted some ten thousand sheep for the British army in the winter of 1778. According to Olivia Hull of the *Vineyard Gazette*, "Red Coat Hill served as a lookout over the harbor during the Revolutionary War, but during an 1778 invasion known as Grey's Raid, Red Coats invaded the hill, leaving a garment behind."[17] The name lingers to this day.

Another unique street in West Tisbury is Yellow Brick Road, which runs off Old County but lacks a sign. Beaten Path leads from Buttonwood Road, parallel to State Road. The Scotchman's Bridge Road extends from Pan Handle Road, by the Agricultural Hall, yet is abbreviated to Scotchman's Lane on the approach to the Granary Gallery. The bridge crosses the Mill Stream, which feeds the Mill Pond, where swans gather.

Tea Lane garners publicity in Chilmark. This rugged one-lane dirt road stretches from North Road to Middle Road. It bears a sign that attributes the name to antagonism between the American colonies and Great Britain. Tea Lane earned its name for a colonial Captain Leonard who smuggled contraband tea aboard his ship in England and transported it onto the Vineyard, secreting the tea in his aunt's cellar by this dirt road. He avoided the British tax on tea, but rather than tossing

it in the harbor as the Boston miscreants later did in 1773, he was able to share it with friends and family.

Oak Bluffs hosts Rogers Way. I asked former selectman Roger Wey about this. It turns out that property owners and developers Mary and Russell Rogers requested the name from the Oak Bluffs Planning Board. It was granted without discussion, and Roger Wey just smiles about it.

Two other streets nearby were named for wives of developers: Carol Lane and Lesley Avenue. Both run off County Road, in Oak Bluffs.

John Lamb, son of Helen Lamb—founder of Camp Jabberwocky, a summer program for people with cerebral palsy and other disabilities—recalled his mother's sense of humor when she encouraged her son to make mischief: "There was a sign on Lawrence Avenue, near where the Landers family lived. We renamed the sign to read Landers Lane. It stayed like that for years until it faded and was replaced with two signs, one that read Lawrence Avenue and another Landers Lane."[18]

Dodgers Hole, off the Edgartown–Vineyard Haven Road, was named for the adjacent kettle pond where snapping turtles reigned supreme. Swimmers were advised to dodge the snappers.

At one time, a large wooden fork was attached to a tree at the intersection of Linden Lane and Barnes Road. The instigator would tell his friends to find his house by taking a right at the fork in the road.

A historic name is remembered in the street sign for Heath Hen, along West Spring Street in Vineyard Haven. The extinct guinea hen lives on in name only, although a gigantic statue of the ill-fated bird startles cyclists along the bicycle path around the airport.

One of the more intriguing Vineyard street names wards off unwelcome visitors. Don't tarry along Goah Way. The name is chiseled in a large boulder. According to the Tisbury Planning Board, Douglas Hakey developed the land and thus could select the street name. "I don't know how I came up with it," he said. "I threw an *h* in there to give it a northern accent."[19]

Naming his street took place in the late 1990s:

> *At the planning board meeting, I thought it was kind of funny. Paul Adler was at the same meeting. Both of us were there just to get the names of our streets approved. Paul had his plan laid out on the table. The spokesman for the board asked me, "What do you want to name your street?" I said "Goah Way." He said, "No, really, what do you want to name it?" I said, "Goah Way, and my alternate names are Getta Way and Know Way."*

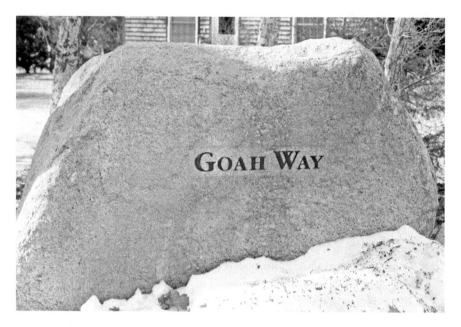

"They found a rock. It cost me $800 to have it engraved. Carved in stone. More than $100 a letter," said Doug Hakey. *Photo by Joyce Dresser.*

This girl on the Board came out with the comment: "Too many streets in town are named for daughters or wives." And there was Paul Adler, asking to have his street named for his daughter, Alyssa. The planning board voted unanimously in favor of Goah Way.

The saga of Goah Way continued: "They threw a sign up; someone stole it. Threw up a sign a second time, and they stole the pole and the sign." Hakey was amused at the reaction to the name. Further investigation turned up Goah Ways in both Sunderland, Maryland, and Springdale, Washington.

The Underground Railroad

S lavery was integral to the creation of the United States of America. During the Constitutional Convention in 1787, slavery was an underlying embarrassment for the northern colonies and a demand of the South. The Three-Fifths Compromise, which counted a slave as three-fifths of a white person for representation purposes, seemed workable at the time. Shortly after that compromise, Congress passed the First Fugitive Slave Act of 1793, which required runaway slaves be returned to their masters.

There were slaves on Martha's Vineyard in the eighteenth century. As historian Henry Kittredge pointed out in his 1930 tome, "This subject may as well be disposed of now as later, for the settlers brought a belief in slavery with them."[20] In the seventeenth and eighteenth centuries, those residents on the Cape and islands who could afford slaves bought and kept them.

The earliest record of the sale of an African American on Martha's Vineyard was by a grandson of Thomas Mayhew, Sam Sarson, in 1703. An innkeeper in Chilmark, Ebenezer Allen, owned slaves valued at £200 in 1734. When the estate of Joseph Chase was probated in 1741, there was "one Negro boy" listed among his possessions. In another deal, Black Manoel was bought in 1768 in trade for a quantity of whale oil by two Vineyard captains. Ferryman Abraham Chase owned four slaves, and Colonel Cornelius Bassett, another Chilmark innkeeper, had slaves valued at £300.

Zacheus Mayhew of Chilmark promised to free his slaves, including Sharper Michael. Michael had two children with Rebecca, a slave from Guinea. Sharper Michael died on Gay Head, atop the cliffs, warding off a

British man-of-war, in 1777. Two years later, Rebecca's children were sold to Joseph Allen of Tisbury.

Around 6,000 African Americans, both free and enslaved, lived in Massachusetts during the Revolution. On the Vineyard, less than 2 percent of the population was African American, 46 of 2,414 people. That number rose to 8 percent prior to the Civil War, 298 of 3,812.

The Quock Walker court case effectively outlawed slavery in Massachusetts in 1783. Attorney Levi Lincoln, of Worcester, successfully argued that all men are born free. While it granted freedom for Quock Walker, other slaves had to petition the court for their freedom.

By 1804, all the northern states had outlawed slavery, which made escape to the North inviting. And with the South's growing dependence on cotton (and therefore, the need for more manpower to grow and harvest it), slaves did escape.

Prior to railroads, cotton was transported north by sailing ships and later steamships. These vessels proved to be a means of escape for slaves, who stowed away, sometimes with the implicit consent of the crew. Indeed, some slaves were "hired out" as crew aboard commercial vessels, with their wages paid to the slave owners. These hired-out crewmembers were amenable to stowaways, as they were only a step away from freedom themselves. Free blacks often found work as sailors aboard ships or as stevedores, handling cargo on the waterfront, again making escape an option. Once a slave got away, he could melt into the waterfront of coastal communities.

And there were many coastal communities in the shipping trade. Charleston and Savannah and other southern cities shipped cotton north in the 1820s and 1830s. Cotton was even shipped to England, as the Industrial Revolution expanded with the invention of the cotton gin and spread of mills devoted to spinning and weaving.

In the decades prior to the Civil War, Vineyard Haven was a bustling port for coastal schooners. Vineyard Sound became one of the busiest routes in the nineteenth century; thousands of ships sailed by Martha's Vineyard annually.

New Bedford, along Buzzard's Bay in southeastern Massachusetts, became a mecca for runaway slaves. With an active Quaker community and waterfront connections, the city attracted those seeking freedom from slavery by providing access to routes north and into Canada. African Americans, brave enough and fortunate enough to escape slavery, headed for New Bedford, which became known as the fugitives' Gibraltar.

Warren Doty, of Chilmark, has studied the Underground Railroad. "No escaped slave ever was returned or captured in New Bedford. New Bedford was a bastion of the free black community," he said. The Quaker population

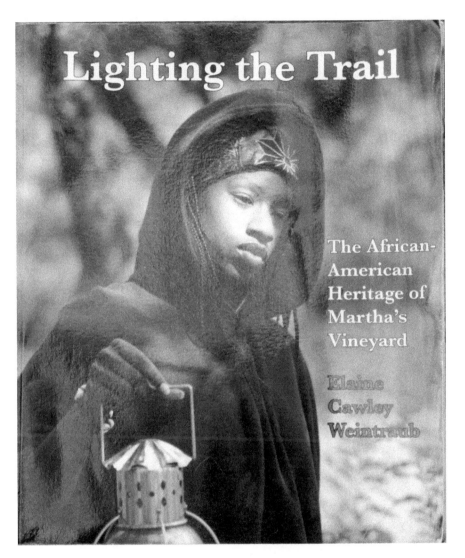

Lighting the Trail illuminates the African American Trail on Martha's Vineyard. *Photo of Jaquelle Servance as Rebecca Amos on the cover of* Lighting the Trail *by Charlie Utz.*

was united in support of fugitives who struggled for freedom. Doty says, "Sailors helped escaped men aboard. The African American crew knew what was going on, and it became the informal railroad. The captain probably knew what was going on; he got paid for delivering his cotton, and kept quiet about any escaped slaves on board."[21]

There was no system or schedule to the way slaves found their route to freedom. "The current thinking is that the Underground Railroad was very

informal," says Doty. "Slaves escaped and managed to get to New York or Pennsylvania and found safe houses. They hooked up with abolitionists."[22]

The informality and illegality of the Underground Railroad presented challenges to determine specific stations or safe houses for fugitives. The escape route was often available simply through luck for the brave black (mostly) men who managed to get away from the masters and sought support along the road to freedom. A number of slaves who escaped came from the border states of Maryland, Virginia and Kentucky, as they were closer to the abolitionist cities of Philadelphia, New York, Syracuse, New Bedford and Boston. Fewer slaves escaped from the Deep South, as their routes were much longer and fraught with danger.

One assessment of the trials of the fugitives spells it out:

> *Their routes were many and varied, they often traveled in disguise, through woods and farms, by wagon, boat, and train, hiding in stables and attics and store-rooms, and fleeing through secret passages; but the destination they sought was always freedom. In areas where escaped slaves often traveled, stories or legends of the Underground Railroad's routes and stations still persist. No one knows how many fled from bondage along its invisible tracks: as many as 100,000 before 1830 and 1860? As few as 30,000? No one may ever know, because secrecy was crucial; few records of the railroad's activities survive.*[23]

"No one knows for sure how many enslaved Americans escaped with the help of the Underground Railroad....What we do know for sure is this: in 1860 the number of people in bondage in the United States was nearly four million."[24] That projects a very small percentage of passengers on the Underground Railroad. "Estimates—guesses, really—suggest somewhere between 1,000 and 5,000 per year between 1830 and 1860."[25] Author Eric Foner, in his *Gateway to Freedom*, continues:

> *Slaves of every age absconded, but most were in their twenties (the average age of the adults was 25.5), their prime working years, when their economic value to their owners was at its peak. Reasons for escape: brutal physical abuse; threat of sale, breaking up families and friends. And groups or families of slaves did escape together, though the predominance was single men. Means of escape included trains, horses, boats and walking.*[26]

As the steam railroad expanded across the Northeast in the 1830s, engines evolved into powerful locomotives. Sailing ships predominated along the

coast, even as steam-powered vessels were introduced. Improved means of transportation made escape more possible.

As the rails improved, so did the telegraph, which expanded communication, linking communities, especially along railroad routes. Communication within the African American community at the time was compared to an underground telegraph, which allowed slaves to communicate from different plantations. "By the 1850s, many escaped slaves appear to have been able to communicate with loved ones in the South."[27]

Jim Thomas, of Oak Bluffs, leads his Spiritual Choir in slave songs of the antebellum South. Thomas says the songs the slaves sang were a means of communication, an early form of social media, designed to send a message about a meeting or share information about a route to freedom. Masters forbade their slaves to speak to one another, so slaves resorted to spiritual song.

Thomas says, "The slaves used a safe language to communicate. [There were] always at least two levels of messages in these songs: one, the obvious to the master, the other to the slaves. Until after the [Civil] War, no one wanted to believe the slaves were communicating a message."[28] Spiritual songs were laced with inspiration on the route to freedom and surreptitiously shared among slaves. "Go Down Moses" refers to Harriet Tubman. Angels in song are conductors or supporters of the Underground Railroad. "Swing Low Sweet Chariot" speaks to the means of escape. While this was not an organized or unified effort, spirituals were shared when a slave was sold from one plantation to another, and the message passed along.[29] Thus a network of underground communication evolved within the African American population of the Deep South.

The term Underground Railroad is attributed to an 1840s newspaper. "In 1842, an Albany abolitionist newspaper reported that twenty-six fugitives had passed through the city, and that 'all went by the 'underground railroad.'"[30]

Terminology gave the movement the character of a railroad, a modern, efficient means of transport. "Escape routes came to be known as 'lines,' runaways were 'freight,' safe places were 'stations,' and helpers were 'conductors.'"[31] The underground concept was an admission both of its illegality and that it was outside the parameter of public acceptance. Individuals and organizations that supported the Underground Railroad were linked to create "a network of local individuals and groups, in contact with one another, committed to assisting fugitive slaves. Their efforts expanded, and collectively they became known as the underground railroad."[32]

The informal nature of the railroad was evident: "A Massachusetts abolitionist noted, 'We had no regular route and no regular station.'"[33] The

route to freedom grew from humble, fragmented efforts to a more cohesive, united and subversive organization. "By the 1850s, what had been a 'rough network' of safe houses in southern Pennsylvania had evolved into a well-organized system for assisting fugitives."[34]

While the danger and bravery fell primarily on black shoulders, it was risky for the white people who harbored the fugitives, as the federal response to fugitives grew more intense in response to the pleas of southern slave owners. "The underground railroad represents a moment in our history when black and white Americans worked together in a just cause."[35] With the current popular interest in the Underground Railroad, it is important to recognize that it was a joint effort between black and white. "In the entire history of slavery, the Railroad offers one of the few narratives in which white Americans can plausibly appear as heroes. It is also one of the few slavery narratives that feature *black* Americans as heroes—which is to say, one of the few that emphasize the courage, intelligence, and humanity of enslaved African-Americans rather than their subjugation and misery."[36]

Historian Foner goes on, "The story of the underground railroad remains one with an extraordinary cast of characters and remarkable tales of heroism, courage, and sheer luck."[37] As the political divide over slavery widened, Foner states that the underground railroad, although operating undercover, attained a "quasi-public" status in the years leading up to the Civil War.

Abolitionists worked not only to free slaves but also to provide opportunities once the fugitives settled in the North. "Underground railroad operatives were deeply involved in campaigns for equal citizenship for northern free blacks, including the right to vote, access to public education, and economic opportunity."[38]

And Canada offered a safety zone for fleeing fugitives. "Canada offered blacks greater safety and more civil and political rights—including serving on juries, testifying in court, and voting—than what existed in most of the United States."[39] Historian Foner continues: "The vast majority of runaway slaves went onward from New York City headed to Canada via that region, where antislavery sentiment had spread rapidly and the underground railroad operated with amazing impunity."[40]

The Freedom Principle was a key element in the northern perception of slavery that emerged in the 1840s. The Freedom Principle essentially was a northern policy that argued that slaves who accompanied their masters to the North were deemed free. It declared: "That the moment a slave, other than a fugitive, set foot on free soil, he or she became free."[41] This led to

an increase in the number of escaped slaves who walked away from their masters. In the North, once they left their masters, the slave was considered free and could legally remain in the North or move on, most likely to Canada.

The Freedom Principle challenged the basic concept of slavery. It played out in Falmouth, across Vineyard Sound, when a slave named Dinah escaped. This tale was reported in an address to the Falmouth Historical Society in 1910:

> *On the September day that her master was preparing to take his family and possessions back to the South, he took Dinah with him to the post office to obtain a permit to return her from a free state to a slave state.* [This was the requirement of the time.] *Falmouth women in the kitchen of the private home that housed the post office drew Dinah into the kitchen with them, told her she would be free if she stayed in Falmouth. Offering to hide the willing girl, they rushed her to the cellar and stationed her behind a big pork barrel. Quickly, they then pretended to help the searchers.*

The tide had turned, the sails were set and the captain of the slave owner's ship could wait no longer. The master had to board his ship, without Dinah, and set sail.

Dinah was free. She renamed herself Anness and married Joseph Ray, a free African American who delivered mail from Falmouth to Martha's Vineyard. Anness and Joseph were parents of the journalist and abolitionist Charles Bennett Ray (1807–1886). Joseph Ray ferried abolitionist Samuel Gould across the sound to Martha's Vineyard in 1837, and Anness signed the Falmouth Anti-Slavery petition in 1839.[42]

The Freedom Principle was anathema to southerners, who demanded that fugitives be recaptured. That demand was granted in September 1850 when the Second Fugitive Slave Act was signed into law by President Millard Fillmore. The primary intent of the act, which was incorporated into the Compromise of 1850, was that runaway slaves must be returned to their masters. The Freedom Principle was outlawed. Federal commissioners were authorized to determine who was a fugitive. Slaves had no right to testify in their own defense. A local individual could be deputized to serve as a marshal and required to assist in the recapture of a runaway. Severe penalties were levied on anyone who harbored a fugitive, and federal authority was deemed supreme to states' rights. Furthermore, no protection was offered to free blacks who might be captured by slave catchers.

During the 1850s, more than 300 fugitives were captured and returned to the South by federal commissioners. In Boston, two significant cases involved such rendition. Thomas Sims was publicly whipped when he was sent back to Georgia. When fugitive Anthony Burns was led from his jail cell to board a ship to be returned to Virginia, there was fear the angry crowd would riot, so 1,600 soldiers marched Burns to the ship. Yet during that same era, more than 400 fugitives were aided and abetted by the Boston Vigilance Group. So even as Boston returned two slaves to the South, hundreds more were assisted on their road to freedom. In 1854, it was reported, "The underground railroad never before did so large a business as it is doing now."[43] Northerners were aggressively involved in the Underground Railroad.

From the time he founded the *Vineyard Gazette* in 1846 to the cusp of the Civil War in 1860, editor Edgar Marchant reprinted numerous reports on slavery, yet very few involved the Vineyard. A perusal of the *Gazette* files indicates an increased awareness of slavery in other parts of the country. Marchant managed to capture news stories that presented both sides of the slavery issue that served to educate his readers.

The conundrum that faced the North was that more cotton required an increase in slaves in the South. Southern legislators demanded that escaped slaves be returned, as they were considered property. Reinstitution of the slave trade was considered in South Carolina. An editorial was published in the *Richmond Examiner*: "It is all a hallucination to suppose that we are ever going to get rid of African slavery, or that it will ever be desirable to do so. Let us make up our minds, therefore, to put up with and make the most of the institution."[44] Sam Houston stated that the South did not create slavery; it must be accepted as an existing fact.[45]

In the North, abolitionists in the American Anti-Slavery Society sought to repeal the original 1793 Fugitive Slave Law. *Uncle Tom's Cabin* sold 160,000 copies in eleven weeks. Success of the Underground Railroad in northern cities was promoted. In Chicago, seventeen slaves escaped from Missouri, followed by a U.S. marshal, a posse and three military companies. "A great excitement was occasioned by the presence of slave catchers."[46] Articles on potential emancipation were published in the early 1850s and served to broaden the horizon of Vineyarders.

The following piece was printed by the *Vineyard Gazette* in June 2, 1854, but referred to an incident that occurred a century earlier: "Escape of a fugitive slave from a vessel in Edgartown harbor. The public has been greatly occupied recently with several cases of reclamation of fugitive slaves." *Gazette* editor Edgar Marchant described a fugitive slave named Esther, who was

aboard the sailing ship *Endeavor*, in Edgartown Harbor. According to the story, the woman engineered her escape, as reported by a seaman on the ship: "We bound her feet to a crowbar, and tied her hands behind her, and put her down into the hold and laid the hatches."[47] In the morning, Esther was gone, as was the *Endeavor*'s long boat. "And we were all on board, but asleep, when she went away, and knew nothing of her going away." The *Gazette* offered no explanation for reprinting this story, which was apparently recounting a historic escape from July 28, 1743.

Two lines in the *Vineyard Gazette* of May 11, 1855, describe a local incident with an excruciating lack of detail. The entire piece reads: "Slaves—We learn that two or three slaves, fresh from the South, arrived in town last week. They were conveyed to New Bedford by one of the colored residents of Chapaquidic."

That is the extent of the story. There is no indication where the fugitives came from, how they reached the Vineyard or even how many there were. In any case, they were transported to New Bedford by residents of Chappaquiddick, and we can only assume they continued on their road to freedom.

As the country edged closer to war, the schism over slavery widened. Again, the *Gazette* shared national events for the edification of its readers.

Henry Ward Beecher raised $500 at Plymouth Church in Brooklyn to help pay for a slave's freedom. The congregation was "in as great suspense as the girl herself, forgot the sacred character of the day and gave vent to their joy in a loud clapping of hands."[48]

Another heart-wrenching story recounted how a woman raised enough money to purchase her daughter at a New Orleans slave market. "The mother was so much affected with joy of having succeeded in retaining possession of her child, that she swooned away and was carried out of the saloon."[49]

The issue of slavery on a national level played out in the local political field, "so embittered is the public sentiment upon slavery," with such a "hold upon the public mind of this absorbing and irritating matter."[50] People sought to send Dr. Daniel Fisher of Edgartown to Congress but preferred a more partisan representative because slavery dominated politics. The article commented that there was "too great an occupation of the public mind with slavery, to the neglect of many vital interests of the country."

For many on the Vineyard, including editor Marchant of the *Gazette*, slavery was elsewhere, another state's concern, a southern situation. However, in September 1854, the *Vineyard Gazette* had no choice but to recount the dramatic escape of a stowaway fugitive that took place right in Vineyard Haven Harbor.

Above: Fugitive slaves made their way to New Bedford and on to Canada. Vineyard Haven Harbor sheltered sailing ships in the mid-1800s. *Photo by Joyce Dresser.*

Left: The *Franklin* had a fugitive slave aboard who escaped onto the Vineyard. *Photo of the* Shenandoah, *modeled after the nineteenth-century revenue cutter* Joseph Long, *in Vineyard Haven Harbor, by Joyce Dresser.*

The escape is dramatically recounted, but the report omits specific details that may have implicated local citizenry. Interestingly, nearly seventy years later, another description of the events was recalled in a 1921 issue of the *Vineyard Gazette*. And a descendant shared a third version of the story in his 2001 recollection.

From the files of the *Vineyard Gazette* of September 22, 1854, we learn of this daring escape. The bark *Franklin*, from Jacksonville, Florida, was bound for Hallowell, Maine. The *Gazette* states the ship "had a slave on board, who secreted himself in the hold, when the vessel was loading. During the night, while the vessel was lying at anchor, he took a boat, and made good his escape to the shore; since which his whereabouts have been known only to a select few."

A week later, on September 29, the story continued: "The slave, in company with the colored cook, had left the bark clandestinely at Holmes Hole [Vineyard Haven] with the boat, and had not since been heard from." For a week, Captain Cook waited in Holmes Hole for approval from the Custom House to recapture the slave. "Captain Cook tried to return the Negro to the Deputy Collector, Mr. Worth. The Negro absconded Tuesday night or Wednesday morning." No other word was heard about the cook who accompanied the slave.

The slave landed on West Chop, proceeded to Gay Head and entered a swamp. Sheriff Lambert of Chilmark obtained a warrant for his arrest. *Photo by Joyce Dresser.*

"We are very happy to say the fugitive in question arrived safely in this city and is now in a place of safety," reported the *New Bedford Standard Times*. *Photo by Joyce Dresser.*

Two women from Holmes Hole brought food and women's clothing to the slave, who was hidden in a swamp in Gay Head and,

> *after lingering a moment in the suburbs, were furnished with a vehicle. All emerged from the swamp, and jumping into the wagon, drove direct to Manainshe Bite [Menemsha], and entered a boat with a good pilot on board. After the arrival of the boat at New Bedford, the women took themselves to the residence of an abolitionist, and arrangements were made by him, which resulted in the forwarding of the slave to Canada.*[51]

Again, details are omitted; the two women and pilot could not be traced.

Years later, the *Vineyard Gazette* of February 3, 1921, published an article entitled "The True Story of a Fugitive Slave," by Netta Vanderhoop, granddaughter of the woman who led the fugitive to freedom. Some details were changed, but the story was essentially consistent with the original.

"It was a few years before the Civil War," when this story took place. A sailing ship from Charleston, South Carolina, loaded with lumber, was headed to Boston when the captain learned that a fugitive slave was a stowaway. The captain decided to put in to Vineyard Haven and turn the

slave over to the sheriff, as "the laws of those days were so rigid that men generally neither dared nor cared to assist escaping slaves."

They reached the harbor and informed the customhouse of the slave. The captain told the slave, assumed to be Edgar Jones of New Brunswick, South Carolina, to remain in the captain's cabin. When the captain went ashore, "The sailors who had been friendly to the fugitive told him that the only chance of escape was in successfully getting away from the ship."

The slave rowed ashore that night, and "for three days he hid in the woods and cornfields, living on raw corn." He sought work from local farmers. "One of the men told him to go to Gay Head and the people there might give him work. So he came up the Island and stayed for nearly a week at Mr. Moses Bassett's, working for his food and lodging."

Postmaster William Vanderhoop saw the sheriff riding into Gay Head. The sheriff requested assistance to capture a sailor who had jumped ship. The postmaster's wife, Mrs. Vanderhoop, overheard the request. Mr. Bassett was having breakfast with Edgar Jones when the sheriff showed up. Jones dashed into the woods.

"'A dollar for each of you if you will help me catch that man,' cried the officer." They were unsuccessful.

Mrs. Vanderhoop's curiosity was aroused by the commotion. "'I wonder if that poor fellow the sheriff is after is a slave,' she said to herself as she kept glancing out the door."

Mrs. Vanderhoop urged the men to allow the slave his freedom, which they did. However, the slave was cornered that night. "The sheriff saw him but did not dare attack him alone, so a watch was stationed in the tower of the lighthouse while he went to get his sons to help him effect the capture."

That night, "Mrs. Vanderhoop went up stairs and quickly secured an old dress and bonnet, and returned to the place [where the slave was hidden]." She urged him to put on the woman's clothes. "The fugitive obeyed the kindest mistress he had ever had and step by step approached his freedom." She took him home, hid him and fed him.

"By the time the sheriff returned with his men, the whole reservation [Gay Head was not a town then] was aroused by this man-hunt in the North. Ninety-nine per cent of the men were determined that the slave should not be taken." Still, the sheriff had to obtain a warrant before he could search the houses; getting one would take six hours.

Certain arrangements were hurriedly but effectually made. Midnight was set for the time when Mr. Samuel Peters should take his sailboat and carry

the slave to New Bedford, for the people of Gay Head knew that if he once reached there, he would be perfectly safe.

In some way the sheriff got wind of the true state of affairs and failed to put in an appearance.

The boat got away safely and Mr. Peters and his charge reached New Bedford before seven o'clock the next morning. There Edgar Jones remained for some time, working about the wharves. Everybody liked him, and he was kept at work, for his employers highly valued his services.

Sometimes he came back to see Mrs. Vanderhoop. He called her Mother, brought her money, and said he loved her very much. Just before the war broke out he went to San Francisco and has never been heard from since, though many think he went to the war and was killed. Thus ends a true story of the ante-bellum days, and for years thereafter people used to come and shake the hand of brave Beulah Salisbury Vanderhoop and thank her for the womanly part she had played.

This 1921 version parallels much of the original tale that was reported in the *Vineyard Gazette* of 1854.

A third version of the Vanderhoop tale, or perhaps another tale completely, surfaced in 2001. Captain Charles Vanderhoop Jr. was interviewed by Linsey Lee of the Martha's Vineyard Museum and related the story heard from his grandmother, Beulah's granddaughter Netta Vanderhoop, who penned the 1921 newspaper story:

My great-great-grandfather William Adrian Vanderhoop was born in Suriname, Dutch Guiana. He was the first Vanderhoop to come here, and he married Beulah Ocooch Salisbury. Their house was a link on the Underground Railroad. My great-great-grandmother, Beulah Vanderhoop, would help escaped slaves find their way free. She'd hide them in the barn—there was a false cellar underneath the barn floor.

My grandmother told of who she worked with in Vineyard Haven—of course that's where the big sailing ships come in, Holmes Hole—and how they got them [escaped slaves] up here. Then they usually could get them out on the boats going back and forth to New Bedford carrying fish. I think it was a total of eight slaves that she saved.[52]

That is how the Underground Railroad worked on Martha's Vineyard. And if Captain Vanderhoop's recollection is to be believed, eight slaves were rescued by his great-great-grandmother.

At the height of the abolitionist movement, on the cusp of the Civil War, the most prominent African American in the United States spoke on Martha's Vineyard.

Frederick Douglass wrote about his background as a slave in modest terms in his autobiography. He made his way to freedom, devoted his life to the abolitionist movement and then undertook efforts to improve the lot of former slaves. His public statements bear out his unusual and charismatic life story.

Of his ancestry, which was largely unknown, Douglass wrote, "There were others who told me that their fathers and mothers were stolen from Africa. This to me was important knowledge, but not such as to make me feel very easy in my slave condition."[53]

Of the brutality of being sold and breaking up families Douglass wrote, "No one could tell among which pile of chattels I might be flung. Thus early, I got a foretaste of that painful uncertainty which in one form or another was ever obtruding itself in the pathway of the slave."[54]

Frederick Douglass escaped slavery, made his way to New York, changed his name and mingled with the stevedores along the waterfront. He found safe haven among African American abolitionists and continued on to New Bedford. Once he tasted freedom, he never looked back.

Douglass wrote about his new life:

> *The freedom from bodily torture and unceasing labor had given my mind an increased sensibility and imparted to it greater activity. Beat and cuff the slave, keep him hungry and spiritless, and he will follow the chain of his master like a dog; but feed and clothe him well, work him moderately and surround him with physical comfort, and dreams of freedom will intrude.*[55]

His *Autobiography* declared that freedom was taking the step from being a slave to becoming his own master: "Give him a *bad* master and he aspires to a good master; give him a good master, and he wishes to become his own master."[56]

Frederick Douglass toured the Northeast and Europe. Twice he gave public speeches during a visit to Martha's Vineyard in the autumn of 1857. His first address was at the Edgartown Town Hall; his second was at the Congregational church (now Federated Church) in Edgartown.

The *Gazette* reported on November 27, 1857:

> *We hope the learned lecturer will aim more to enlighten his audience than to excite their prejudices against the South; that he will disappoint the expectations of those who can see good in nothing but agitation, by*

On Frederick Douglass: "His arguments were very logical and doubtless deemed conclusive. He is a fluent and powerful speaker and commands uninterrupted attention." *Courtesy of Hilary Wall, librarian for the* Vineyard Gazette.

endeavoring to allay rather than excite hatred among the members of the States of the Union. Let peace and concord, and brotherly love, be his watchword, rather than that which leads to strife and all manner of evil.

The following week, December 4, 1857, the *Gazette* reported, "Douglass, the colored orator, addressed a very respectable, though not large audience, at the Town Hall, on Saturday evening last, on the Unity of the Races."

Douglass's second lecture took place before a full house at the Congregational church:

> *His subject was slavery, or the slave power in the United States. He failed to handle his subject with the power and ability he displayed in his former lecture, and hence some little disappointment was manifested by the public at the close of the performances. We think Mr. D. is entitled to great respect and to the best wishes of all true lovers of the colored race.*[57]

Martha's Vineyard lies within a trio of seacoast communities, each with links to the Underground Railroad. Nantucket, Cape Cod and New Bedford harbored fugitives.

Nantucket hosted a free black population; 10 percent of the island's 7,300 population was African American in 1830. The white community was strongly influenced by Quakers, "an enclave for abolitionists." Frederick Douglass made one of his first calls for abolition on Nantucket, which had "privately owned homes where runaway slaves were sheltered in the early 1820s."[58] Donald Yacovone, senior associate editor at the Massachusetts Historical Society, said, "Because of the maritime connections, certainly Nantucket stands out and I would not be at all surprised if seacoast towns on the Cape served fugitive slaves."[59]

Research on the Underground Railroad on Cape Cod bears accounts similar to communities across the Northeast. "Although connections to the Underground Railroad are largely undocumented on the Cape and islands, local lore and historians describe the region as a likely destination for maritime escapes and an active aid to the nearby abolitionist hotbeds of Boston and New Bedford."[60] With numerous seaside harbors in the Northeast, it is likely African Americans escaped when sailing ships docked along the coast.

Cape Cod inns have capitalized on their abolitionist history. A trapdoor at A Little Inn on Pleasant Bay, Orleans, is said to lead to a hiding place for fugitives. Yarmouthport's Old Yarmouth Inn has a hidden door, thought to have provided passage for runaway slaves. In West Harwich, a trapdoor leads to a cellar believed to be a hiding place for fugitives at the Tern Inn and Cottages. "The cellar was used to hide runaway slaves awaiting ships going to Canada." In Barnstable, Ashley Manor has a secret passageway that was used to harbor escaped slaves. "Allegedly, slaves climbed down a ladder, still found in the closet of the King George Suite, to reach the cellar, then fled into the night."[61]

The population of Martha's Vineyard was not influenced by abolitionist Quakers like Nantucket or New Bedford. Greater emphasis was placed on abiding by the law than skirting it. Still, newspaper accounts and local lore indicate Vineyarders participated in Underground Railroad activity.

"On Martha's Vineyard, the free black population also flourished, reaching a high of 571 blacks in the 1840 census. Robert Hayden, author of *African-Americans on Martha's Vineyard and Nantucket*, is quoted, 'We have not identified any physical sites, but certainly we know there were fugitive slaves that came ashore and were protected by individuals and families.'"[62] Specific sites in antebellum houses might have provided refuge for fugitive slaves. On the Vineyard, there are no definitive sites, although three possible places come to mind.

In Edgartown, the old Daggett House, on North Water Street, had a secret staircase and a concealed room. Captain Thomas Pease opened it as a tavern in 1751, and fifty years later, it was converted to a private home by Captain Timothy Daggett. A secret door was disguised in a bookcase: "Once you've found and unlocked the secret latch, you enter a tunnel of small, wooden,

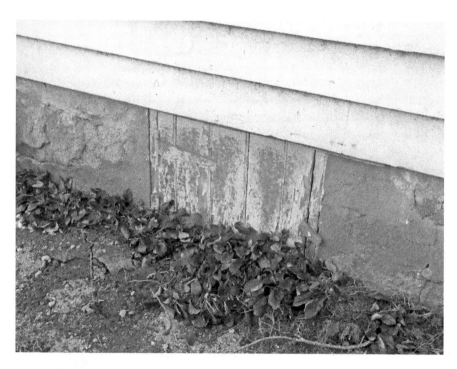

A secret door in the foundation and a concealed closet in a sea captain's house might have been used to harbor a fugitive slave. *Photo by Thomas Dresser.*

eighteenth-century steps curving up to still another door—small and cribbed like a pre-Revolutionary closet."[63] It is plausible to consider the staircase and room, secreted from the rest of the house, as a place for a slave to be hidden.

In an old sea captain's house in Vineyard Haven, overlooking the harbor, a homeowner uncovered a closet secreted behind another closet, beneath the main staircase. One of the floorboards had been cut and could have been raised to serve as a means of egress through a concealed door in the foundation. The sea captain sailed on the same whaling ship on which William Martin, the great-grandson of slaves, once served as a first mate. Coincidence?

In Aquinnah, the Vanderhoop family shared the story of the false floor in a barn that concealed a room where fugitive slaves were hidden. The Vanderhoop family story has been passed down through the generations and confirms that Vanderhoops were conductors on the Underground Railroad at the Gay Head station. Other sites across the Vineyard have been mentioned, but without corroboration they cannot be identified.

In 1998, the National Park Service created Network to Freedom, "a system of federally designated, locally managed Underground Railroad sites around the country."[64] We can only speculate on the fortitude of fugitives and locals working together on the railroad to freedom. And with the opening of the Smithsonian National Museum of African American History and Culture in 2016, the courage of African Americans who traveled the Underground Railroad is memorialized and recorded, making it available for all to acknowledge and appreciate.

3

VINEYARD SHIPWRECKS

As an island, Martha's Vineyard has seen its share of major calamities in the waters off its shores. Shipwrecks can be caused by dramatic weather conditions and human or mechanical error. Often a shipwreck occurs due to a series of compounding factors rather than a single incident. The most horrendous wrecks include great loss of life, yet two episodes stand out for the rescue of all hands aboard.

An intriguing aspect of shipwrecks is that they are accidental, unplanned incidents. Therefore, they preserve the past as it once was, rather than how someone wants it to appear.

Drama arises when a ship founders at sea. The fifty-year era from 1880 to 1930 includes perhaps the most dangerous nautical activity in Vineyard waters. In this chapter, I consider four major shipwrecks, and the effects of a single storm that wrought havoc along the Eastern Seaboard, especially in Vineyard Haven Harbor. Of the wrecks' remains, Vineyard historian Dorothy Scoville wrote, "They lie buried in the constantly moving sands or they have been pulverized by the pounding surf."[65]

THE CITY OF COLUMBUS

In 1884, the *City of Columbus* ran aground off Gay Head, on the southwest corner of Martha's Vineyard, in the middle of the night, in the middle of

a storm, in the middle of winter. More than one hundred people drowned in the freezing waters. The wreck was caused by human error, yet both weather and mechanical malfunction contributed to the crisis. Dorothy Scoville deemed the wreck of the *City of Columbus* the "most disastrous wreck of the century."[66]

The 272-foot, elegantly appointed *City of Columbus* was launched in 1878. Nickerson and Company operated the steamship on the Boston to Savannah route, through Vineyard Sound, one of the busiest nautical routes in the world. In 1870, the keeper of the Gay Head light reported 26,470 vessels passed through Vineyard Sound.

On January 17, 1884, at 3:30 p.m., Captain Schulyer Wright, with a crew of forty-five, piloted the *City of Columbus* out of Boston Harbor, with eighty-seven passengers bound for the sunny South to seek solace from the wintry weather of the North. The ship's hold was laden with a cargo of northern goods: shoes and apples, farm implements and lumber.

The first twelve hours were uneventful. The ship steamed around Provincetown at the tip of Cape Cod, as the canal would not be dug for another thirty years.[67] Passengers enjoyed a multicourse meal, mingled with one another and retired to their cabins on the top two decks.

As the ship entered Vineyard Sound, passing lighthouses that guided it along the shore of Martha's Vineyard, Captain Wright continued at the helm. However, as the ship passed Nobska Light, in Woods Hole, the captain ventured to catch a brief nap in his cabin. He had been at the helm for nearly twelve hours, and it was bitter cold. He put Second Mate Augustus Harding in charge; the man at the wheel was Quartermaster Roderick McDonald, and lookout Edward Leary was assigned to keep an eye on the waters as the boat plowed through Vineyard Sound.

It was a clear night with a waning gibbous moon, more than half full, so there was sufficient illumination in the night sky. The captain dozed in his cabin. The man at the wheel kept his course, as he understood it. The lookout noted, "The lighthouse seemed closer than usual." And there is no record what the second mate was up to, although he was in charge. For whatever reason, the vessel veered off course at 3:30 a.m. and ran aground onto an undersea boulder, a glacial erratic some thirty feet below the surface. This great rock, known as Devil's Bridge, lies a half mile off shore, marked by a buoy the lookout failed to see. The ship was within sight of the Gay Head lighthouse, yet was not seen by the lighthouse keeper when it foundered.

As the ship crunched onto the underwater boulder, the captain awoke and ordered reverse engines to back off the rock. His order caused a gaping

DISASTER OFF MARTHA'S VINEYARD

THE SINKING OF THE *CITY OF COLUMBUS*

THOMAS DRESSER

The wreck of the *City of Columbus* off Gay Head in the winter of 1884 was the Vineyard's worst sea disaster. *Sketch in* Harper's Weekly, *February 2, 1884 for cover of* Disaster Off Martha's Vineyard, *published by The History Press.*

hole to be torn open in the hull as the ship unsuccessfully backed off. Water began to fill the hold. A strong wind, fetching across Buzzard's Bay, caused the *City of Columbus* to list to port. Passengers and crew awoke and rushed up and out onto the sloping deck; great waves washed them into the frothing, freezing waters below.

As the *City of Columbus* canted to port, lifeboats proved inaccessible. The ocean water was very cold, the air was freezing and dozens and dozens of people drowned. A few able-bodied crew, the captain and the most agile male passengers clambered up a mast and held on to the frozen rigging as the ship listed farther in the gathering storm.

Around 7:00 a.m., more than three hours after the wreck, assistant lighthouse keeper Frederick Poole spotted the ship, with its crew and passengers hanging from the spars. The community of Gay Head was alerted and sprang to action.

Six local Wampanoag of the Humane Service rowed for hours over tumbling waves to rescue those who still clung to the masts in the freezing winter weather. "The water was chock full of wreckage and we thought we'd be stove any minute," remembered Jim Cooper. "But all I worried about was my new boots, left there on the bank. I knew father would jaw some if I came home without them."[68]

Lighthouse keeper Horatio Pease reported, "The neighborhood was aroused. At daybreak I put a sheet over the light as a signal." *Photo of Wampanoag rescuers, courtesy of the Connie Sanborn collection.*

The revenue cutter *Samuel Dexter* happened on the scene, and more people were rescued. But the majority of those aboard ship, 103 of 132, perished. Bodies washed up along the shoreline and were picked up and brought to Capawock Hall in Vineyard Haven for identification.

None of the thirty-five women and children aboard ship survived. More crew were rescued than passengers. With the *City of Columbus*, there was little or no effort to rescue passengers; the captain, officers and crew fended for themselves. It was a devastating disaster, a quarter century before the *Titanic*.

"Here and there, in today's old Vineyard homes, are treasured pieces of furniture from the *City of Columbus*. As for the ship itself, boilers and engine were removed but storms left only a shattered hull."[69]

There was an inquiry into the disaster, and Captain Wright lost his license. The Wampanoag were hailed as heroes for their bravery and awarded gold and silver medals, which were greatly appreciated, as well as financial remuneration. Beyond the heroism of the Wampanoags, there was little to celebrate.

As a result of this disaster, passenger safety began to take priority, as did lifesaving drill practice.

THE PORTLAND GALE

In terms of maritime destruction and chaos, the most devastating storm to strike Martha's Vineyard in the nineteenth century was the Portland gale of 1898.

The Portland gale was a monstrous blizzard that blew up along the east coast of New England on November 26–27, 1898. The storm was named for the wreck of the *Portland*, a side-paddlewheel steamer en route from Boston to Portland, Maine, that sank off the coast of Cape Ann, Massachusetts.

The sinking of the *Portland* was the worst steamship disaster off New England prior to 1900. The wreck lies off Gloucester. The exact location is undisclosed, as it is within the federally protected Stellwagen Bank National Marine Sanctuary. John Fish and Arne Carr of the American Underwater Search and Survey Organization discovered the *Portland* wreck in 1989; it is listed in the National Register of Historic Places.

In the course of the gale, more than 150 ships sank, including 40 in Vineyard Haven Harbor alone. Some two hundred people drowned when the *Portland* sank, and another two hundred died in the storm.

The passenger list of the *Portland* went down with the ship, so there is no record of the exact number of people who drowned. *Courtesy of the Connie Sanborn collection.*

Our purview is the damage to ships and sailors seeking shelter from the storm in Vineyard Haven Harbor, known as Holmes Hole prior to 1871. Sailing ships often drew into the protected harbor, which runs more than a mile inland. The East and West Chops, named for the choppy waters formed by currents around the peninsulas, provide a protective shield for the harbor.

On November 27, 1898, that protective shield proved insufficient to withstand the monstrous storm.

"It was the most destructive disaster ever known in Vineyard waters and was shared by the entire New England coast," wrote Dorothy Scoville. The story builds: "In a blizzard of sleet and snow, schooners dragged anchor and crashed into other vessels, carrying them down in a tangle of rigging. Men were swept overboard or caught in the wreckage. Some froze to death when they took refuge in the foundered ships. Only heroic endurance accounted for the survivors."[70] Dorothy Scoville published her account of the disaster nearly three-quarters of a century afterward.

The report in the *Vineyard Gazette* of December 1, 1898, paints a more immediate picture of the scene of destruction, headlined: "A Terrific Storm." The storm struck Saturday night and lasted through Sunday. The moon was full. The storm occurred well before weather forecasting or radar could provide warning.

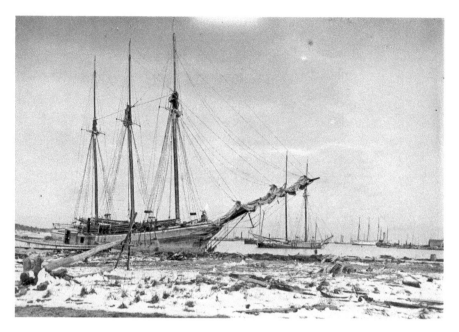

Above and opposite: The *Vineyard Gazette* of December 1, 1898, described the Portland gale: "Sea faring men declare that not in the last half century has there been a gale so severe to shipping interests as this. All along the coast the shores are strewn with wrecks, and the loss of life is appalling." Richard L. Shute took photographs shortly after the Portland gale. And a photographer named Chamberlain, who worked at the corner of Circuit and Narragansett Avenues in Cottage City, took photos of the destruction. *Photos courtesy of the Martha's Vineyard Museum.*

Published just days after the event, the *Gazette* account is impressive in its detail: "Vineyard Haven's noble harbor presents the scene of direct disaster. Vessels were constantly driven ashore, many of them to be dashed to pieces." At least ten seafaring men died in the storm. Four schooners lost their masts. More than twenty schooners were washed ashore; numerous vessels were sunk, and the *Gazette* listed all of them. "Aside from the wholesale wreckage at Vineyard Haven, the most serious disaster resulting from the storm in this section of the state was the wreck of the steel steamer *Fairfax*—270 feet long, off Sow and Pigs," a reef south of Cuttyhunk.

Rescue efforts were undertaken across Vineyard Haven Harbor. Five men were taken off the *EJ Hamilton*, a three-masted schooner; six men were saved from the *Annie A. Booth*, a three-masted lumber schooner; and four men were plucked from the lumber schooner *Leora M. Thurston*. The captain of the *Thurston* froze to death on the rigging, awaiting rescue.

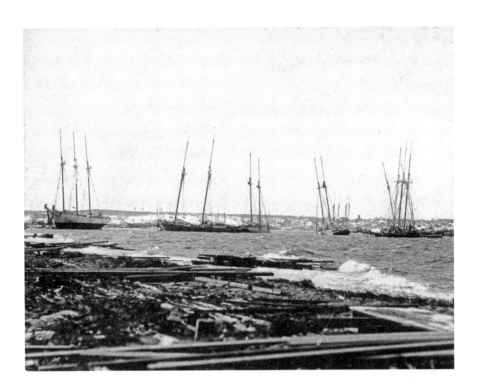

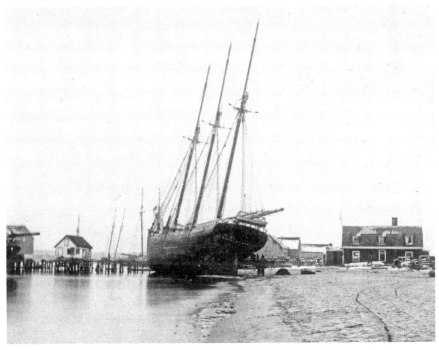

The Marine Hospital in Vineyard Haven provided medical care to survivors, and the Vineyard Haven Bethel offered food, clothing and shelter to nearly one hundred shipwrecked sailors following the storm.

One unusual result of the storm, which affected the harbor for months, was that "the light three-masted schooner *Newburgh* went completely through the wharf at Vineyard Haven, so that at present her bow and stern project from the sides, thus blocking transportation to the wharfs." Photographs of the *Newburgh*, which hailed from Windsor, England, indicate it became part of the local lore, with its bowsprit pointing over the landscape. For five months, the 136-foot *Newburgh* was entrenched in Union Wharf. An addition to the wharf was created to allow boat traffic around the *Newburgh*'s bowsprit. In May 1899, the ship was dragged from the wharf, refloated and towed to New York; it left a memorable imprint on the harbor.

The incident was revisited in a 2013 story in the *Martha's Vineyard Times*:

> *The British schooner* Newburgh, *returning from Staten Island to its homeport in Nova Scotia, was one of nearly 100 coasting vessels that sought shelter in Vineyard Haven's harbor that night. But there was no shelter from this monstrous storm. The 500-ton schooner (nearly the mass of a modern Steamship Authority freight boat) parted both anchor chains and crashed into the upper portion of Union Wharf. Over the next few hours the heavy seas and high winds drove it steadily through the wharf, splintering it apart.*[71]

The *Newburgh* proved to be one of the lucky ones: it suffered relatively little damage. Another forty vessels, of which more than half were schooners, were sunk or ran ashore during the storm.

The *Bertha Glover*, laden with lime, lay burning in Vineyard Haven Harbor a week after the gale.

Off Tarpaulin Cove, on Naushon Island, the seven-man crew of the *Lunet* perished. The *Lunet* was carrying coal to Calais, Maine. "Owing to the heavy seas, her crew could not have escaped."[72] And the crew of the sloop *Jenne* of Nantucket were lost off Nashawena Island as well.

In Oak Bluffs, the two-masted *Island City* washed ashore. Bystanders were unable to reach the vessel to rescue three men who had climbed into the rigging. When the ship came ashore, all three men had frozen to death.

Edgartown Harbor was apparently spared. All the boats there were saved, though many had pulled in their anchors. On land, "about a score of chimneys went by the board," and "the engine house of the Martha's Vineyard Railroad was completely wrecked."[73]

The Portland gale proved a disaster without equal in the annals of Martha's Vineyard nautical history. Although some ships were unscathed, the damage and destruction impacted the entire island community.

"Diver Arne Carr made extensive explorations of the harbor in the early 1960s and located several of the wrecks from the 1898 storm. Most of the wreckage was fairly low to the bottom and heavily silted."[74]

MERTIE B. CROWLEY

"The wreck of the *Mertie B. Crowley* endures as one of the most thrilling tales of heroism at sea. Miraculously, no lives were lost."[75] This story is one of bravery in the face of harsh weather conditions. It is the story of seamanship above and beyond the call of duty. The rescue of the crew ranks as a high point in the battle of man against the ocean.

The *Crowley* was one of only eleven six-masted schooners ever built. Bound from Baltimore to Boston, with a cargo of coal, it ran ashore on January 23, 1910. The headline in the *Gazette* read: "Wrecked on Wasque. (Crew clung to foremast.)"

The *Mertie B. Crowley* was launched in 1907 and stretched nearly 300 feet in length, with masts towering 120 feet above the deck. The ship was nearly 50 feet wide. The *Crowley* carried tons of coal and was one of the most efficient ships of the Coastwise Transportation Company.

The crew had the benefit of a steam engine to raise and lower the massive canvas sails on the six masts. This ship was as long as a football field.

Aboard ship, the crew consisted of two mates, an engineer, ten African American seamen and a cook. And Captain William Haskell brought his wife.

Luxurious accommodations included a brass bed, a pump organ, a large bath and a spacious parlor with upholstered chairs screwed to the floor to prevent sliding. A clothes press and galley pantry added to the amenities.

The route of the *Crowley* was reviewed a century after the wreck:

> *These huge schooners were designed and built specifically to carry cargoes up and down the East Coast. Considered more efficient than railway shipping, these vessels sailed past Martha's Vineyard on a regular basis.*[76] *… During its trip to Boston, she encountered periods of fog, rough seas, and a storm with 50- to 60-mile-an-hour winds. Vessels this size were hard to pilot, especially in fog, because the captain could not see the bow of his*

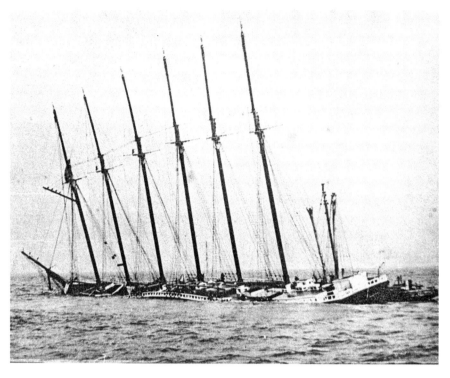

The *Gazette* assigned blame: "The wreck was due directly to the man at the wheel in taking Edgartown light for that of Block Island." *Photo courtesy of the Martha's Vineyard Museum.*

> *vessel, some 400 feet in front of him. Disoriented, the* Mertie B. Crowley *grounded on the west side of Skiff's Island Shoal, off Chappaquiddick, on Sunday January 23, 1910 at 5:35 in the morning.*[77]

The captain was confused in the fog, as indicated by Scoville: "Edgartown harbor light was a fixed white beam shining distantly over the dunes. It had been mistaken for the fixed white light that marked Block Island. Now they were on Wasque Shoal, a finger of sand pointing out from the eastern edge of Edgartown."[78]

"The ship went hard aground on the Wasque shoals. Too far from shore for an easy rescue from the landside, crew members went aloft in the foremast and lashed themselves to the rigging to stay alive."[79]

The *Vineyard Gazette* of January 27, 1910, carried the full story on page seven, headlined as "Six Master Wrecked." The newspaper filled three columns with copy about the daring rescue led by Captain Levi Jackson: "The story of the saving of the lives of Captain William H. Haskell, his wife

and crew of thirteen men, is one of the most thrilling tales in the history of sea heroism, along this section of the Atlantic coast." The piece goes on: "Five brave men went out to battle with the seas," as the vessel was "pound[ed] to pieces on the reef on the south side of the island."

Townspeople on shore watched the dramatic rescue unfold. The *Crowley* was too far off shore for a breeches buoy (a seat on a rope for sailors to slide to safety, akin to a zip-line). A week later, on February 3, 1910, the *Gazette* included further details: "Terrific storm had prevailed upon the ocean, and the great seas resulting there-from had struck upon the coast with a fury and strength that was commented upon in the town three miles distant where the roar of Old Ocean when lashed to anger is an unusual sound."

When the ship ran aground, at five thirty on Sunday morning, the crew, along with the captain and his wife, climbed into the rigging of the foremast. They "had lashed themselves to the rigging of the rapidly sinking 296-foot six-masted schooner."[80]

The *Gazette* described the ten-hour ordeal of the crew hanging on in the rigging. Wind pushed the stern of the vessel toward shore, so waves washed broadside up and onto the decks. It was the middle of January. The temperature was below freezing.

Edgartown's Levi Jackson captained his thirty-two-foot power sloop *Priscilla*, and Captain John Slater was at the helm of his rescue boat *Viking*. At 9:00 a.m., the *Priscilla* and *Viking* steamed out of Edgartown Harbor and sailed the twelve nautical miles around Cape Pogue to reach the wreck. The *Priscilla* anchored nearby. The revenue cutter *Acushnet*, from Woods Hole, was off shore but drew too much water to approach safely.

As the rescue vessels approached the wreck, great waves continued to wash against the ship. The *Crowley* began to break up. After five hours of ceaseless pounding, the hull broke in two, and the forward cabin was lifted off; only the stern cabin and masts remained above water. The crew, the captain and his wife remained in the masts.

Captain Levi Jackson, whose father had died in a failed rescue off Cuttyhunk in 1893, had a four-man crew, "stout-hearted fishermen all."

Saving the captain's wife was the first order of business. "Henry Kelley made it to the *Crowley*, and rescued Mrs. Ida Haskell, wife of the captain, who had to jump 30 feet from the rigging into the moving dory below." The account continues: "Mrs. Haskill, marshaling the courage which she had shown throughout, braved the jump from the rigging to the bobbing dory, and one after the other, the rescue was completed."[81] The cook jumped but missed, and the dory capsized with rescuer Patrick Kelley in it. Kelley

righted the boat, rescued the cook and was picked up by another dory. The *Priscilla*, braving ferocious wind and frightening seas, saved everyone aboard the *Crowley* after an anxious seven-hour ordeal.

"How the heavily loaded *Priscilla* arrived safely in Edgartown is another story of courage, resourcefulness and ability. Again and again, the *Priscilla* seemed to hover on the edge of destruction. The rescued crew clung to whatever offered a handhold, while Captain Jackson's men bailed with frantic concentration."[82] Townspeople at the pier gave three cheers when the *Priscilla* safely reached Osborn's Wharf in Edgartown and unloaded the weary seamen.

The sailors were cared for at the Edgartown Fishermen's Association. The captain was treated for nervous shock and exhaustion at the Marine Hospital in Vineyard Haven, now Martha's Vineyard Museum.

The next day, the crew of the *Priscilla* returned to remove a sealskin coat, a diamond ring, money, two bracelets and clothes. Salvaged gear from the ship included rigging and sails, the boiler and steering apparatus.

"It was an historic moment for Edgartown. Captain Levi Jackson, Henry Kelley, Patrick Kelley, Louis Doucette and Eugene Benefit were recommended for Carnegie Hero Awards which recognized acts of heroism in civilian life."[83] In awards akin to the *City of Columbus*, the Massachusetts Humane Society gave silver medals and forty dollars to each of Levi Jackson's four men and to him. Receiving the Carnegie medals was gratifying for the crew of the *Priscilla*; their descendants treasure the medallions to this day.

Relics and artifacts from the *Mertie B. Crowley* can be found around the island. A timber from the *Crowley* is at Chilmark Community Center.

"Five brave men went out for battle with the seas, and seven hours later returned with one woman and fourteen men all taken out of the rigging of a vessel pounding to pieces on the reef of the south side of the Island."[84] All six masts and the hull were lost to the seas.

Paul Jackson, Levi Jackson's grandson, has a collection from the wreck. Of his grandfather, Paul said, "He was always a lucky person. He spent his whole life on the water. He was five feet tall and weighed 120 pounds. He always wore an oil coat and boots. The ocean didn't bother him. His nickname was Rye-De-Di-Die [ready to die]."[85] The saga concludes: "Old sea captains residing here state that they know of no act of bravery that ever exceeded that displayed by Jackson and his men."[86]

PORT HUNTER

A week before the armistice was signed to end the First World War, a cargo ship bound for Europe bearing army supplies for American forces, the *Port Hunter*, collided with a tug boat off East Chop, Martha's Vineyard. It was November 2, 1918.

The *Port Hunter* left Boston on November 1, under Captain William Stafford, to join a convoy in New York. The plan was to sail together, to protect against the threat of torpedoes from German U-boats. The *Port Hunter* was a 5,500-ton British freighter, laden with army supplies for forces fighting in France: leather jerkins (jackets), long woolen underwear, wool socks, olive drab shirts and pants, wool puttees (covers the leg from knee to ankle) and wool soap. Additionally, the ship carried trench candles, steel rails, eight hundred sets of railroad car wheels, railroad engines, motorcycles and steel billets (structures to house soldiers).

It was the middle of the night, and a light fog had set in. By the time Captain Stafford of the *Port Hunter* realized he should have turned the wheel to avoid collision, it was too late. The tugboat *Covington* rammed the bow of the *Port Hunter*, which caused the larger ship to sink rapidly in the unforgiving waters on the western edge of the Hedge Fence shoal, a mile and a half off East Chop. Stafford allowed his ship to founder on the shallow shoal rather than deeper water. The rescue effort was engineered without incident.

The crew of fifty-three was transferred to the Seamen's Bethel. No one was injured, but many sailors had just pants and boots. The manager of

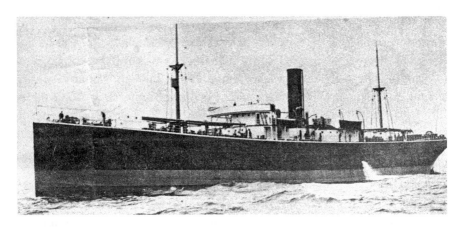

The collision was caused by pilot error. There were neither mechanical nor weather problems. Each captain assumed the other would turn. Neither did. *Photo courtesy of the Martha's Vineyard Museum.*

the telephone company organized a committee of Vineyarders to gather clothes, food, money, fruit and tobacco for the stranded crew. The Red Cross served dinner. The female employees of the telephone company helped out. "The men of the town provided the smokes."[87]

The *Vineyard Gazette* carried the news on page three, reporting, "British steamer…was beached after colliding with a seagoing tug."

The *Gazette* of November 7, 1918, gleefully noted the end of the war was in sight: "Here in Edgartown the people are cheering, the church bells are ringing, the whistles are tooting, the dogs are barking, the autos are honking and verily it looks as if the old town might turn itself inside out." The armistice was signed four days later, on November 11.

Vineyarders wasted no time scavenging the sunken ship. Salvaged items were quickly sold. "For a time it was 'finders keepers' in the salvage work and there was a brisk business in selling salt damp articles spread out on the Vineyard Haven wharf, up in Menemsha, at an Oak Bluffs harbor pier and on the Edgartown wharfs or wherever a boat would unload."[88]

Stan Lair later recalled the excitement generated by all this "free" merchandise: "There was a man, an old gentleman right ahead of us, going along, pulling stuff up, his name was Shubael Vincent. He was putting his initials on every box that he came along, 'S. V.,' 'S. V.,' throwing them up into the bushes, and the boys were coming along right behind them and picking them up and making off with them!"[89]

It was not until months after the wreck that scavenging was restricted. In the meantime, the cargo of the *Port Hunter* created an economic boom on the Vineyard.[90]

In February 1919 the War Department signed a contract with entrepreneur Barney Zeitz of New Bedford to oversee salvage operations of the *Port Hunter*. This was the great-uncle of Tisbury stained-glass artisan Barney Zeitz.[91]

"Now this Barney Zeitz," recalled Stan Lair, "he hired the sanitary laundry in Oak Bluffs, run by Mr. Nichols, and he employed quite a few people there, all fifty or so people, to launder these things. They'd been in salt water of course and they were washed, and they were pressed and packaged and sold to mainland buyers."[92] Salvage operations continued, and tales of salvage steals and deals resonate to this day.

The *Port Hunter* clung to the shoal and then became mired in a court case in 1934. The insurance company sold the wreck to a William Fitzgerald in 1920. For the next fourteen years, the *Port Hunter* remained "on a shoal against which navigators were duly warned by long established buoys and that the vessel's mast at all times appeared above the water no doubt led the

owner and authorities to regard further marking as unnecessary." Fitzgerald hired a man from Vineyard Haven to guard his wreck.

"As late as September, 1933, he [Fitzgerald] was in conference with one T.J. Smith, of Providence about salvaging the hull and its contents," wrote the judge in the case. Fitzgerald and Smith discussed the wreck but had no formal agreement.

In early October, Smith was seen "placing his marker over the vessel as indicating his ownership." He started salvaging for himself.

"As soon as the claimant was seen removing machinery from the hull, notice was sent to the libellant [Fitzgerald] by the party whom he had employed to keep a watch upon the wreck and, as a result, these [court] proceedings were instituted."[93]

The judge ruled Smith was in the wrong. "I know of no principle of admiralty law which enables one to 'stake out' a claim to a derelict by floating over it barrels." The *Port Hunter* remained under Fitzgerald's control.[94]

In an article published in the *Vineyard Gazette* nearly thirty years later, Oak Bluffs resident Sam Low described how he and three teenage friends, Arne Carr, Willy and Dick Jones, searched the wreck of the *Port Hunter*.[95] It was the summer of 1960: "I cannot describe the true impact of what I saw, let it suffice to say that I have never seen anything so mysteriously beautiful and exciting as the dark form that confronted me there, sixty feet beneath the surface of the ocean."

The four teenagers were careful, but curious in their underwater exploration. "The bow of the freighter was well defined and rose for about thirty feet. The whole ship was encrusted with some sort of brown sea growth, but the plates and anchor port of the freighter were still clearly defined. It was a clean wreck!"[96] The *Port Hunter*'s railings were outlined against the ocean surface.

And now we know who is in charge:

> *Large tautog* [black porgy or blackfish] *swam in and out of the open hatches and lurked in the shadows cast by the twisted wreckage. Smaller fish had taken up housekeeping in the few remaining pieces of superstructure. The fish had taken command of the* Port Hunter *and seemed to resent our intrusion as they eyed us with curiosity.*
>
> *Now the* Port Hunter*'s bones are picked clean and she lies at peace on the sand of Hedge Fence shoal, final resting place of the most productive wreck the Vineyard ever has known.*[97]

JOHN DWIGHT

Rumors of rumrunners ran rampant on the Vineyard during Prohibition, from 1920 to 1933. And the saga of the *John Dwight* lingers as an unsolved mystery of this era. There is little question about what happened: the ship was scuttled south of Nashawena Island in Vineyard Sound. But we don't know who did it. Or why.

Prohibition was a result of the temperance movement that gained traction in the nineteenth century. A black market developed in rumrunning because the Eighteenth Amendment to the Constitution forbade the sale and distribution of hard liquor. "Martha's Vineyard, as well as the rest of New England, took a lively interest in rum running during Prohibition days from 1920 to 1933, when it ended."[98]

To circumvent the law that restricted the sale of alcohol, a supply or mothership would anchor off the Vineyard coast. Smaller vessels approached and ferried rum or whiskey to an inlet, where it was off-loaded into vehicles and distributed for local consumption. Participants were well aware of Coast Guard efforts to intercept and capture rumrunners and seize their illicit cargo. In fact, rumor has it that young Vineyarders enlisted in the Coast Guard simply to misdirect efforts to stymie the rum trade.

"Small, fast boats played a cat and mouse game with the slower Coast Guard patrol boats. They loaded rum from an off shore supply ship and ran it in to some secluded shore where it was picked up by trucks or passenger cars with extra heavy springs that disguised the weight of the load."[99]

The *John S. Dwight* was a small wooden freighter, built in 1896, with a single propeller serviced by a coal-fired boiler that fed its steam engine. The vessel was 107 feet long and 27 feet wide and drew nearly 8 feet. Its cargo was bootleg booze.

The following piece appeared in the *New York Times* on April 6, 1923, with a dateline of Vineyard Haven, Massachusetts: "When a heavy fog which had prevailed for hours lifted today, the Cuttyhunk coast guards [*sic*] sighted a vessel about 150 feet long, apparently a steam trawler, flying what appeared to be distress signals. As they watched, the craft suddenly sank." It was 7:30 a.m. on Friday, April 6, 1923.

The initial assumption was that the crew had abandoned ship after a collision with another vessel in the fog. Lifeboat davits were open, implying lifeboats had been launched, but no survivors were found.

The *Dwight* was a former naval vessel, the USS *Pawnee*, used to salvage coal from sunken barges. After service in the navy, the *Pawnee* was sold to

private owners, who renamed it the *John Dwight*, its original name. Over the winter of 1923, two captains arrived in Newport claiming they were the new owners of the *Dwight*. They assembled a crew of about a dozen men. The ship was overhauled and refitted for its new function. The captains gave their destination as New York but instead steamed to Buzzard's Bay.

The Cuttyhunk mail boat stopped by the anchored vessel on Thursday afternoon, April 5. Captain Loverledge spoke with a member of the crew aboard the *Dwight* who informed him they had engine trouble and would soon be underway. Captain Loverledge reported, "The steamer appeared to be loaded down." Shortly thereafter, another vessel, the *Dorchester*, heading north to Boston, spotted the lifeboat davits empty. The *Dorchester* indicated three men were seen rowing hard toward Naushon Island, in the Elizabeth Island chain off the Vineyard.

"The mystery was compounded the next day," reported the *Vineyard Gazette* of April 12, 1923, "when bodies of her crew were found floating amongst bottles of bootleg ale in Vineyard Sound, an area which had been searched the day before." Eight bodies were recovered on the western shore of Martha's Vineyard. The men wore life preservers, yet all had drowned. Seven were ashore; an eighth man was found in a small boat. "He had fashioned sweeps [oars] from strips of board, which he tore from the inside of the boat, locks cut of strips of canvas tore off a belt, and arranged a

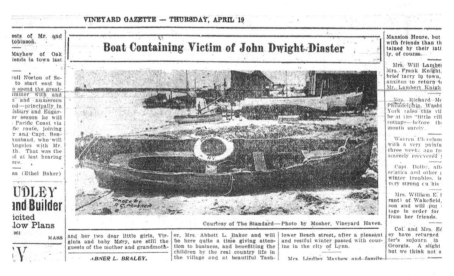

The sailor in the lifeboat was First Mate Henry King, son of one of the elusive captains. Note the misspelling in the headline. This was published in the *Gazette* on April 23, 1923. *Courtesy of Hilary Wall, librarian of the* Vineyard Gazette.

working combination with which to row." His name was Harry King; he was the son of the captain.

The two captains who had initially purchased and refitted the boat were not among the bodies recovered. "One popular theory is that the captains and perhaps some of the crew scuttled the steamer and murdered its crew in order to swindle them out of the bootlegging venture," hypothesized the *Gazette*.

The seacocks (valves on a ship's hull near the waterline to allow water into the vessel to cool the engine) were found open aboard the steamer. One of the *Dwight's* lifeboats was recovered on Naushon Island.

The *Vineyard Gazette* shared the news from the Menemsha Coast Guard: "There was no sign of the crew or boats." The story continued. "Coast guards [*sic*] and fishermen searched all day Friday for the mystery wreck or clues to the missing men." It was unclear what had happened. "A score of barrels of bottled ale were retrieved."

It was believed, according to the *Gazette*, that the ship "picked up a cargo from a rum running mother ship, turned back to make her trip to New York, and was anchored in Vineyard Sound, without lights as is the rum trade picture."

A sidebar in the *Gazette* provided additional information. Under a dateline of Newport, Rhode Island, it was noted, "The *Dwight* wintered there, then there was a good deal of activity in late winter; a crew of unknown sailors arrived and Captains Malcolm Carmichael, an old towboat captain and Captain John Foley took over."

The story hints of mystery: "The waterfront theory was that the vessel had gone on rum business. The arrival of the silent crew of strangers, eight or nine in all, served to strengthen the impression. Many cases of liquor have been picked up in the Sound, including ale and Scotch whiskey."[100] A later story noted that Carmichael was said to be the financial brains behind the *Dwight*. Captain John King of Brooklyn, New York, was actually the second captain; King had used the false name of Foley to register the ship.

An ominous, but correct prediction was proffered by the *Vineyard Gazette*: "It may remain a mystery for a long time to come."

Two weeks after the vessel was scuttled, on April 26, 1923, the *Gazette* offered a resolution of sorts: "The two captains of the *John Dwight* have arrived in Havana, Cuba. The mystery surrounding the disappearance of the two captains has been solved. The pair have just arrived here on board a steamer."[101] When the captains were queried about the demise of the *Dwight*, "neither King nor Carmichael would talk about the matter."

A week later, on May 3, it was reported in the *Gazette* that salvage operations were underway, with a question over who should pay. Salvage

efforts from Dukes County and investigators from the Department of Public Safety eventually agreed both sides would share the cost of searching for the ship. Captain George Tilton, an old whale man, oversaw the salvage with his schooner *Herman L. Rogers*. He set out to "search the famous rum ship for evidence that might clear up the mystery surrounding the sinking of the vessel and the loss of eight lives."

On May 17, the *Gazette* reported the long boat of the *Dwight* had been recovered on Naushon Island. A custodian for the Malcolm Forbes estate found it with neither oars nor oarlocks. Inside the small boat were the quarter boards (sign boards for a ship) of the pilothouse of the *Dwight*, "indicating that the boards had been hurriedly pried or ripped away." Could the captains have escaped to Naushon and then made their way to Cuba?

Diver David Curney, who had explored the wreck of the *Port Hunter* in 1919, returned to dive for the *Dwight*. There was no intent to raise the wreck, only to search for bodies and solve the mystery of why the boat was scuttled. Curney dove several times, but the water was icy, the weather was foggy and no determination was made about why the boat sank.

Following Curney's dives, it was reported in the May 24, 1923 *Gazette* that no bodies, booze or booty were in the sunken ship. Small bottles of ale were recovered. The cabin house, mattresses and much of the interior had been washed away by strong currents of Vineyard Sound flowing one hundred feet below the surface. No evidence of an explosion was found in the vessel. The shipwreck remained a mystery, especially as "barrels of liquor…were found floating at the scene of the disappearance."

Stories continued to circulate in the weeks after the sinking of the *Dwight*. James Craven of New Jersey, identified as one of the crew, was said to have been carrying $100,000 in cash when he left Newport. His body was mutilated, though it was determined to be death by drowning, and no cash was found on his remains. "Authorities expressed the belief that the rum pirates, knowing Craven was carrying the large sum of money, attacked the cutter after she left Newport, killed several members of the crew and scuttled the ship."[102]

By summer, the story had become a postscript. The wreck of the steamer had been located, with its hull upright. The navy minesweeper *Falcon* blew it up. Debris and dead fish arose from the blast. The ship suffered the "loss of a cargo of beverage of high value," with "barrels and bottles of beer and ale aboard," according to the *Vineyard Gazette* of July 5, 1923.

The saga lives on in an undated newspaper article with an ominous angle: of the seven men who washed ashore, each man's head had been "bashed in

from behind." The men were "young and clean shaven and all appeared to have come through a terrible free-for-all fight." Then there's the rumor that the sailors' bodies drifted ashore and are buried on Noman's Land.

Chris Hugo is drawn to shipwrecks. His sketch of the *John Dwight* indicates it was "typical of steam lighters with the machinery aft, derrick amidships and a large, open working deck forward for transshipping cargo, dredging etc."[103] The cargo, the bootleg rum, was stored in the bow of the vessel.

The great-granddaughter of Captain King surfaced in 2015, curious about the case:

> *My grandmother* [daughter of Captain King, brother of Harry King] *never spoke about her family. The only one that she said anything to was my brother* [Bill McGrath]. *He had told me about the ship getting sunk. Grandma said the Coast Guard blew it out of the water. A few years after my brother told me the story I stumbled across a newspaper article that was titled "Harry King's Brother Identifies Body." I don't have much info, just that. Captain John King is my great-grandfather, and his son Harry is my grand-uncle.*[104]

The story assumes a more ominous tone as Bill McGrath, grand-nephew of Harry King, adds his comments.

> *I was nineteen when she (my grandmother) told me the story. I just assumed my father knew, as it was his mom, and he knew nothing about it. You do know there were two sons and a father (my great-grandfather) on board. Per the one version of the story I got from Grandma, and there were two. They were smuggling rum from Canada, and the Coast Guard blew them out of the water. After that, she told me (after a couple of brandies), that the Coast Guard boarded them, and they were all killed then, and said it was all about money, and then the boat was scuttled. What interests me is someone claiming to be my great-grandfather was spotted in Havana, Cuba, after that three years later. It would appear there are some varying accounts from that time. I am aware of the corruption within the Coast Guard at that time as well.*[105]

With passage of the Twenty-First Amendment in 1933, prohibition on the sale and distribution of alcohol was lifted, but this intriguing story lives on.

Arne Carr, founder of American Underwater Search and Survey, has explored the remains of the *City of Columbus*, the *Port Hunter* and the *John*

Dwight. He discovered the *Portland* in 1989. Apparently, the rumrunner *John Dwight* was not destroyed when it was blown up by the navy minesweeper. In response to an inquiry on the *John Dwight*, Carr wrote, "The *Dwight* was refound by Brad Luther of Fairhaven. He gave me the position. I have the binnacle, whistle, bell, and numerous beer bottles from it." He adds, "The beer bottles are neat; one has a winding message at the bottom; some are plain; some have brands you would recognize."[106] The mystery of the *John Dwight* continues to intrigue the curious.

And then there's Jimmy Morgan, a Menemsha fisherman who got "hung up" on the *John Dwight*. "When I was dragging around there, it was good fishing for scup. A mile from Nashawena we hung up on the wreck itself. It's scattered all over the area. The engine's still there. Alton Tilton was with me. He knew the wreck was around there, about a mile from the buoy. I dragged up there and got hung up and couldn't get my gear back."[107] Morgan requested assistance from a larger boat that managed to "lift the ground cables and chains from the wreck and got it all clear."

Morgan pulled a souvenir from the wreck. "Come to think of it, I gave a piece I dragged up to the Museum," he explained. "It has wooden tunnels for the planks." Tunnels are pegs that secure the wooden deck boards. "It's three or four feet long, with pegs."

Jimmy Morgan explained that the *John Dwight* originally was a lighter, a boat used to move cargo and "go around wrecks, and salvage what they could." He cautioned, "That's what I remember. But I tell people, whenever you talk to an old-timer, you need to get a second opinion."

4

ISLAND STRUCTURES

Taverns were among the first public structures the Pilgrims built in America. Later came churches and schools. Over the years, habitation evolved to add décor and amenities to define where we live. The hidden history in the buildings of Martha's Vineyard, town by town, reveals unique and unusual structures in our midst.

EDGARTOWN LIGHT

The first lighthouse in Edgartown was built in 1828, alerting captains on their approach to Edgartown Harbor. The lighthouse was so far off shore the keeper had to row out to it. Eventually, a wooden causeway was built to the lighthouse for couples to say their goodbyes on the departure of a whaling voyage. It became known as the Bridge of Sighs. The bridge also served as a site for couples to pursue a romantic stroll.

The keeper's cottage and lighthouse were expanded as the mechanics of fueling the light evolved from whale oil to kerosene to electricity, in addition to illumination by a Fresnel lens. A breakwater was built to protect the structure. A fog bell was added, as was a storage outbuilding.

The original lighthouse and keeper's cottage survived storms for more than a century, but the hurricane of 1938 proved a disaster. The lighthouse was damaged beyond repair by the storm, and the Coast Guard demolished

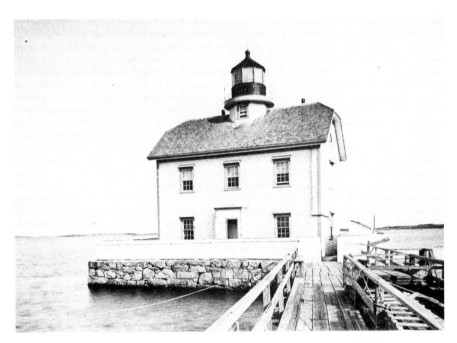

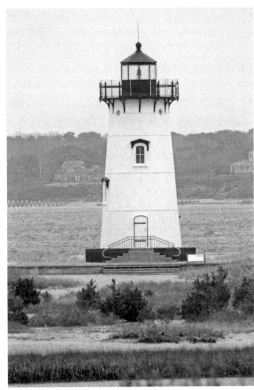

Above: The beacon protruded through the roof of the Edgartown Lighthouse. The light could be seen from fourteen miles out to sea. *Courtesy of Martha's Vineyard Museum.*

Right: The lighthouse was automated and then listed for de-enlistment. Today, it shines on under the jurisdiction of the Martha's Vineyard Museum. *Photo by Joyce Dresser.*

it. Plans were underway to erect a steel skeleton tower with an electric light. Townspeople, led by Henry Beetle Hough of the *Vineyard Gazette*, mounted an aggressive campaign to replace the light with a more suitable symbolic structure than a metal frame.

Phyllis Meras painted a dramatic picture of Hough's role in the lighthouse dispute:

> *The white wooden Edgartown Lighthouse was in disrepair. In 1939, it was more than a hundred years old and had suffered considerably in the hurricane of the preceding year. The Lighthouse Service decided to replace it with a state-of-the-art steel skeleton structure and an automatic light. But all Edgartown—with the "aggressive and accomplished editor" of the* Vineyard Gazette *in the forefront, as reported—"was up in arms." Every week the* Gazette *devoted columns to long editorials "of fiery eloquence."*[108]

A town meeting brought the protest before the U.S. commissioner of lighthouses. The matter was resolved when the commissioner "finally agreed to move a traditional conical-shaped, cast-iron lighthouse from an isolated Ipswich, Massachusetts, site to Edgartown harbor."[109]

The Ipswich Rear Light, a cast-iron tower built in 1881, was no longer in service. It was ferried by barge to Edgartown and was installed on the harbor edge, standing forty-five feet high. After minor modifications, the red light flashed once more, every six seconds. In the 1980s, the Coast Guard felt the lighthouse could be de-enlisted. By then, a local organization, Vineyard Environmental Research Institute (VERI), organized by William Waterway Marks, convinced Congress to allow VERI to assume control of Edgartown Light, as well as the lighthouses on Gay Head and East Chop.

VERI operated the three lighthouses for a number of years; the Martha's Vineyard Museum assumed management in 1994. In 2001, a memorial to deceased Vineyard children was installed with engraved cobblestones surrounding the Edgartown lighthouse base; a chart lists the location of each named stone. In 2007, the Martha's Vineyard Museum installed new windows and a spiral staircase to replace the ladder to the light.

The refurbished and reinvigorated Edgartown Light shines on, under the jurisdiction of the Martha's Vineyard Museum. In season, it is open to the public.

DR. FISHER HOUSE

The Dr. Daniel Fisher mansion stands in stately fashion on Main Street in Edgartown, two doors down from the red brick county courthouse, adjacent to the Old Whaling Church.

Daniel Fisher was born in Sharon, Massachusetts, in 1800. He graduated from Brown University in 1821 and from Harvard Medical School in 1825. Following a short stint at Massachusetts General Hospital, Dr. Fisher was hired by the customs collector to meet the medical needs of seamen and sailors on the island. Hence, he moved to Edgartown.

In 1829, Daniel Fisher married a local woman, Grace Covens Coffin. It was said that the bride's father offered Dr. Fisher his daughter's weight in silver. In any case, the couple had seven children: Daniel, David, Ann, Elizabeth, Leroy, Grace and Carrie.

Dr. Fisher was an enterprising entrepreneur and an aggressive businessman and held an impressive opinion of himself. Besides his medical practice, Fisher owned a wharf on Edgartown Harbor and operated a large whale oil–processing company. He won contracts to provide whale oil to the federal government. He sold whale oil to lighthouse keepers along the

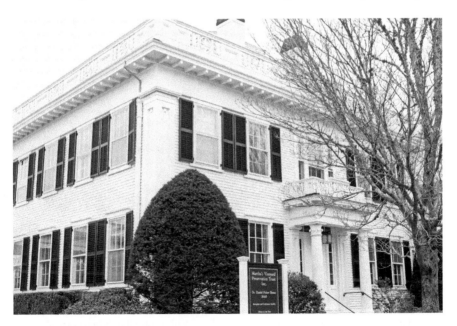

Dr. Daniel Fisher built his house in 1840, a sign he had achieved status as the wealthiest man on Martha's Vineyard. *Photo by Joyce Dresser.*

seacoast. He offered to install streetlamps in Edgartown provided that the town purchase the whale oil from him. It did. Dr. Fisher's name was entered as a candidate for Congress, though it was later withdrawn, as he was not considered a staunch enough abolitionist.

In 1840, Dr. Fisher engaged local carpenter Ellis Lewis as house wright in the construction of his Main Street mansion. Architectural plans and drawings for the Federal-style structure are housed at the Martha's Vineyard Museum. The plans and drawings "are in pen and ink, wash and pencil on paper, and include profiles or sections of architectural ornaments and elements, as well as hand-colored flank and front elevations. There are details of the cornice, roofline, lantern, pilaster caps, roof rail or balustrade, column base and shaft, windows and trim."[110] It is an impressive building.

Dr. Fisher built a spermaceti candle factory (spermaceti is whale oil in the head cavities of sperm whales) that became one of the world's largest. "Fisher's oil storage warehouse was so large that it was colloquially known as 'Dr. Fisher's Fort.'"[111] The National Park Service suggests that "candle making also strengthened the local economy during this period. The largest

Dr. Fisher built a road to West Tisbury to haul wheat to his gristmill in Edgartown. With the ground wheat he baked hardtack to sell to whaling captains for their crews. *Courtesy of the Basil Welch collection in the Martha's Vineyard Museum.*

single maritime-related enterprise which grew up around whaling was the production of whale oil and candles by Dr. Daniel Fisher & Company. This company became Edgartown's largest industry in 1850." And Dr. Fisher founded the Martha's Vineyard National Bank, now Santander.

Dr. Fisher died in 1876.

The Martha's Vineyard Preservation Trust acquired the Fisher house in 1975. It is well maintained and serves as a hub for charitable fundraisers, as well as a site for weddings and private functions. The house and grounds seat 250 people.

HARBOR VIEW HOTEL

In the later part of the nineteenth century, the whaling industry showed signs of faltering. Edgartown businessmen sought to redefine the town as a summer resort community, following in the footsteps of Cottage City (now Oak Bluffs). The Harbor View Hotel led the way with an auspicious entry into the hospitality business. Built in 1891 yet bankrupt by 1892, the Harbor View was bought for $6,600 by a straw buyer, who sold it back to the original owners for $1 and later went to jail for torching his own hotel, the Wesley House, which he had insured for $14,000.

"*Harbor View: The Hotel That Saved a Town* (2014) published by Vineyard Stories, explores the role the hotel played in Island history, and memorializes the many people and groups that have contributed to its survival. The book was commissioned by the owners of Harbor View in anticipation of the hotel's 125th anniversary in 2016."[112]

The book was written by Nis Kildegaard, with photographs by Alison Shaw. In a review of the book, Kildegaard is quoted: "It's the most heavily produced project I've ever worked on. [We set out to] tell the story of the evolution of Edgartown as a summer resort through the lens of the place that started it all."[113]

The review continues. "Every time you turn over another rock there is another story about the history of the Harbor View," Kildegaard said in the review. The *Vineyard Gazette* had encouraged construction of the new hotel in 1890, as a means to stimulate the local economy, following the demise of whaling. "The *Gazette* even reported on a public contest in 1891 to name the new hotel. Some losing entries were Hotel Mizpah, Hotel Nashaquitsa, The Montezuma and Hotel Quinomica."[114]

"It was a long and bumpy road to the unofficial title of Grand Dame of Edgartown," wrote Alex Elvin of the *Vineyard Gazette.* (First photo from 1896; second photo from 1923.) *Photos courtesy of Martha's Vineyard Antique Photos.*

Alison Shaw said, "By the end of doing that book, I thought, this is my favorite undiscovered place on the whole Island for really savoring summer. Just to sit on the front porch there and watch the boats in the harbor and watch the lighthouse. It epitomizes summer on Martha's Vineyard to me, and I wouldn't have said that going into it." She appreciated the opportunity to venture upstairs to survey Edgartown Harbor; she said that was special.

The hotel had minimal records to offer. Jan Pogue, of Vineyard Stories, the company that published the book, said, "They've gone through so many ownerships that little things that you would expect from a hotel that age have

just disappeared." She compared it to a mystery novel, where you peel back layers of history and fill in the pieces of the puzzle from other sources.[115]

"Its porches and windows frame Edgartown harbor and the surrounding landscape, drawing visitors from around the Island and the world. It is a favorite spot to sit back and watch the sailboats in the harbor, the changing skies throughout the different seasons and the fireworks on the Fourth of July."

S. Bailey Norton remembered playing on the hotel's fire escapes during the 1920s and '30s. He was quoted in the review as saying, "What kept the hotel going was the understanding that without it, Edgartown would be a very different place."

"Local ownership, that has always been the successful component of the hotel," said Pogue. "As soon as it got away from that, and it did a couple of times, it began to go downhill. And each time it was pulled back by local ownership."

Robin Kirk, the president of Scout Hotels, which assumed ownership of the Harbor View in 2006, knew very little about the hotel, until he read the book. He said, "It's much more than a coffee table book. It's actually a good read."

Kirk appreciates that the history of the Harbor View Hotel has been presented in book form. "It is part of the fabric that is the community, and I think people like to understand how that fabric is woven," he said. "It is a story that belongs to all our guests and all our employees and our owners, and people who have been involved in the hotel in the past. I think people really want to know and read that story."

Whaling boosted the economy of Edgartown in the mid-nineteenth century but faltered after the Civil War, as the Atlantic had been overfished. The shift from whaling to tourism was precipitated by visits from the New York yacht club, but there was a scarcity of hotel rooms. An effort was made to entice tourists to Edgartown with the Martha's Vineyard Railroad, which ran from 1872 to 1896.

The Harbor View Hotel was built on Starbuck Neck, overlooking Edgartown Harbor, with Chappaquiddick in the background and Edgartown light center stage. The hotel is at the far end of North Water Street, beyond the impressive homes of whaling captains.

When the Harbor View opened, in July 1891, four hundred guests attended the festive celebration. Over the years, the hotel expanded in size and focus and became financially solvent. When the Mattakeesett Hotel, in Katama, was dismantled, a section of that hotel was moved to the grounds of the Harbor View. Another section became the headquarters for the Land Bank, on Main Street Edgartown, by Memorial Park.

Bob Carroll owned the hotel from 1965 to 1989. According to the *Martha's Vineyard Times*, "As much as Bob Carroll enjoyed owning the Harbor View, he says it was never a big moneymaker. 'I'm not sure the Harbor View Hotel has ever made real money. You keep thinking it's going to turn around and make money, but I had to borrow each year to make renovations.'"[116]

In 1974, a young filmmaker named Steven Spielberg filmed a movie on Martha's Vineyard. Among the more memorable moments in the history of the Harbor View was that the cast of *Jaws*, including Richard Dreyfuss, Robert Shaw and Roy Scheider, were booked at the Harbor View.

"When the *Jaws* team called to reserve 50 rooms, Carroll demanded a $25,000 deposit and got it."[117] When the filming of *Jaws* wrapped, Carroll estimated his local enterprises of the Harbor View and the Kelley House, Seafood Shanty restaurant, Edgartown Marine (for water scenes in the movie) and Carroll & Vincent Reality business brought in more than a $1 million.

> *Certainly memorable, was the food fight that broke out at the Harbor View in that summer of 1974 as director Spielberg and his cast blew off steam from a memorably difficult production session. How exactly it started—who threw the first meatball or handful of mashed potatoes—no one can exactly recall. But bartender George Gamble later said the principals were Spielberg and actors Roy Scheider and Richard Dreyfuss. "The three managed to make a real mess," he said. "It was a disgusting sight, seeing them covered in ravioli, cake, and diced fruit." According to one account of the fracas, the combatants rinsed off by jumping into the Harbor View pool.*[118]

Nearly four decades after the success of *Jaws*, the money continues to trickle in. Carroll, who played the part of a selectman in the fictional town of Amity, received regular residual checks from the blockbuster film, which has earned nearly $2 billion. Bob Carroll passed away at the age of ninety in 2015.

OAK BLUFFS: FLYING HORSES CAROUSEL

There's a Carousel in Oak Bluffs town,
The horses don't go up or down,
The horses just go 'round and 'round,
On the Carousel in Oak Bluffs town.

The Flying Horses lays claim as the oldest continually operating platform carousel in the country. It was built in 1876 by Charles F.W. Dare Construction in New York and began service on Coney Island. A similar carousel, also by the Dare Company, is located on Watch Hill in Westerly, Rhode Island.[119]

In 1884, F.O. Gordon, of New York City, purchased the carousel and moved it to Cottage City, as Oak Bluffs was then called. It was situated near the harbor, by the roller rink and giant slide, part of an amusement park atmosphere on the waterfront. The carousel was relocated to its present locale in 1889. The Flying Horses Carousel was sold to Joseph Turnell in 1896 and then to various owners throughout the years before being purchased by the Martha's Vineyard Preservation Trust in 1986.

As noted in the poem on the previous page, the twenty hand-carved wooden horses travel in a circuitous route, affixed to a platform, at a speed of three to four miles per hour. An advertisement in the *Gazette* in the summer of 1886 noted the carousel offered "fun for the old folks as well as for the children." The owner boasted the Flying Horses was lit by electricity and featured inspiring music.

The Flying Horses is among a few carousels that still include a ring machine.
The accessory was once standard on the rides and is the source of the phrase,

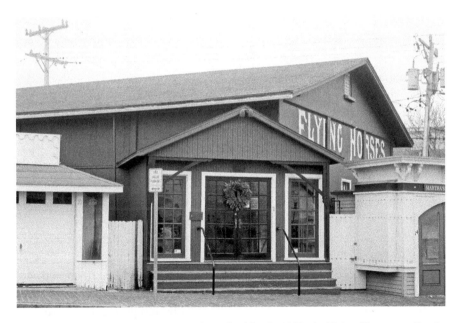

The Flying Horses' brass ring rewards the agile rider. In 1979, the Flying Horses was listed in the National Register of Historic Places. *Photo by Joyce Dresser.*

"catch the brass ring." Once the carousel gets up to speed, an operator swings an arm that dispenses metal rings into the path of the riders. Passengers have to reach out to grab the rings. And yes, lucky riders who catch the brass ring get a free ticket for another ride on the Flying Horses.[120]

The Preservation Trust purchased the Flying Horses to protect it from being taken apart and the horses sold individually. According to the trust, it "undertook an extensive restoration of the Flying Horses, returning the carousel to its original appearance, complete with the historic panel paintings that were done by a Dare factory artist." A carousel conservator restored the horses to their original standards, including authentic horsehair tails and manes and realistic glass eyes. The Wurlitzer organ from 1923 plays music associated with the bygone era that epitomizes the merry-go-round thrill for children and the nostalgic overtones for parents and grandparents.

CIVIL WAR SOLDIER

This noble statue has been stationed in Oak Bluffs for a century and a quarter. While its genesis is convoluted, its presence is outstanding. Drift back through time to piece together its story.

"Standing seven feet tall atop a base of cast iron, mounted on Quincy granite, the Soldiers' Memorial Fountain, as it was formally known, was dedicated before a crowd of hundreds on August 13, 1891."[121]

The story goes that Charles Strahan (1840–1931), a veteran of the Confederacy and publisher of the *Martha's Vineyard Herald*, sought to honor Union veterans to heal the wounds caused by the Civil War. He raised the $2,000 for the statue with subscriptions from his newspaper.

The statue was ordered from a catalogue of J.W. Fiske and Company, which manufactured garden and stable ornaments. Like the Flying Horses, which has a companion carousel, there is a similar Union soldier statue in Rhode Island. The second Civil War statue stands in North Kingston.[122] Both statues are clearly Union soldiers, with the initials "U.S." emblazoned on their belts.

The statue was rededicated in 1925. Charles Strahan, then in his eighties, stood before an assembly of islanders to acknowledge the Union army veterans who eventually paid tribute to those who fought for the South:

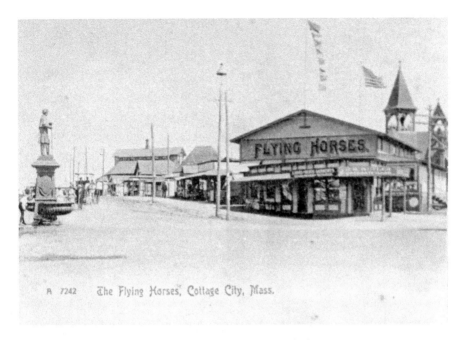

A 7242 The Flying Horses, Cottage City, Mass.

The soldier statue originally stood at the base of Circuit Avenue, adjacent to the Flying Horses. It was moved to Ocean Park in 1930. *Courtesy of the Connie Sanborn collection.*

> *On September 4, 1925, the remaining few members of the Vineyard post of the Grand Army of the Republic came through. Strahan was eighty-six and frail, but able to attend the unveiling of an inscription on the fourth plaque. "The chasm is closed," it read. "In memory of the restored Union this tablet is dedicated by Union veterans of the Civil War and patriotic citizens of Martha's Vineyard in honor of the Confederate soldiers."*[123]

Descendants of Charles Strahan attended the ceremony. Great-nephew Dr. William Strahan noted the family had been

> *deeply divided in the Civil War. Dr. Strahan's great-grandfather on his mother's side was a lieutenant in the Union Army. Great uncle Charles Strahan, on his father's side, was a lieutenant in the Confederate army. They both fought at Gettysburg. With the rededication of the statue today the division in the family has come to a conclusion. "I think the wound has healed and the chasm has closed," said Dr. Strahan.*[124]

The statue was originally situated at the base of Circuit Avenue and housed a water fountain for horses, dogs and passersby. When a traffic light

Reconstructionists removed twenty-two layers of paint and rebuilt the statue with a new scabbard and rifle cast from authentic pieces. *Photo by Joyce Dresser.*

was installed in 1930, the statue was relocated to Ocean Park. Apparently, the move was haphazard, as the statue toppled over, damaging its head, hand and rifle. A local artisan repaired the statue, and the soldier has stood without flinching for nearly a century.

Charles Strahan died on March 24, 1931, at the age of ninety-one. With members of his family, he is buried in the Oak Grove cemetery in Vineyard Haven.

"In 1974, while preparing for the American bicentennial, the Oak Bluffs Parks Commission decided to paint the statue gray to emphasize its tie to the former Confederate soldier. Instead, the paint change left behind the Island-wide impression that the statue was a representation—however weirdly out of place—of Johnny Reb himself."[125]

English teacher David Wilson took a fancy to the statue in 1999 and organized a restoration effort, which included a new hand, new gun and a bayonet scabbard. Local artisan Barney Zeitz recast and painted the zinc-and-iron sculpture; the pedestal was recast, using zinc alloys from the original. At a cost of nearly $80,000, most of it privately raised, the Soldiers' Memorial Fountain was rededicated on August 17, 2001.

"Bagpipes, played by Tony Peak, began in the distance and came nearer as the Massachusetts 54th re-enactors and members of American Legion Post 257 marched to the foot of the memorial. Clouds began to roll in, blocking the splendor of the sun but not the glory of the celebration."[126]

Reverend John Streit spoke at this third dedication. "This monument was conceived and built as an icon of healing—as a testament to our nation's need to come together again in spite of all the killing, all the casualties, all the destruction that both sides endured."[127]

The statue remains the only memorial north of the Mason-Dixon line dedicated to soldiers on both sides of the Civil War.

DENNISTON HOUSE

The Denniston House on Masonic Avenue in Oak Bluffs was built in 1892. It was the site for missionary work by Susan Bradley, who provided a religious and educational haven for immigrants who arrived on Martha's Vineyard. It was called the Oakland Mission Hall.

In 1901, Reverend Oscar Denniston emigrated from Jamaica and worked with Susan Bradley in her mission. "Inside the two-storied, wooden

framed edifice, Mrs. Bradley and Reverend Denniston helped immigrants from Portugal, the Azores and Cape Verde Island to learn English and mathematics—providing them the skills they would need to become U.S. citizens."[128] The facility also served as a spiritual center for African Americans, "where generations were linked by fellowship and worship."[129]

The interior of the building served as a chapel and became increasingly popular as the African American congregation grew under the tutelage of Reverend Denniston, who assumed leadership upon the death of Susan Bradley in 1907. He renamed the facility the Bradley Memorial Church and conducted services in the Baptist tradition.

Reverend Denniston lived in the building year-round, with his wife, Medoria, and five children. People of all faiths were welcome; the congregation included whites, in addition to Portuguese, Wampanoag and African Americans. It was truly an integrated religious service. The space proved inadequate in summer to meet the expanding congregation, so Reverend Denniston rented a former vaudeville theater, Noepe Hall, by the present Strand Theatre, to accommodate the throngs.

For more than thirty years, Reverend Denniston preached to his populace. He was well respected in town and across the island, and when he died in

While the Denniston house has changed hands and status several times, it has yet to find a passionate protector. *Photo by Joyce Dresser.*

1942, he was praised for his welcoming manner and integrated service. In an editorial published in the *Vineyard Gazette*, editor Henry Beetle Hough wrote, "One does not have to look far away to find things to be proud of when considering the career of Rev. Oscar E. Denniston. He helped bring into reality in his generation the conception of America as a land of opportunity, brotherhood and democracy, not by coming here to become rich, but by coming here to build a church."

The congregation of the Bradley Memorial Church continued at various sites into the 1960s and then disbanded.

After Denniston's death, the Denniston house fell into disuse and, today, sits vacant on Masonic Avenue. While the Denniston house has changed hands and status several times, it has yet to find a passionate protector.

VINEYARD HAVEN: MANSION HOUSE

The Mansion House in Vineyard Haven is one of the more impressive Vineyard hotels. It stands sedately on the corner of Main Street and State Road, just beyond the Steamship Pier, and boasts a cupola deck where one can survey the surrounding harbor. It is a majestic structure.

The original Mansion House was built in 1791 on what was then known as Quality Street in Holmes Hole. *Harper's* defined it in 1870 as "an old-fashioned country inn, and as full of comfort, tidiness and snugness as all the old fashioned places are supposed to be."[130] Historian Charles Banks repeated the review and wrote the house was "our most pretentious modern hotel." The Mansion House retains those admirable qualities in the twenty-first century.

The disastrous fire of 1883 consumed the Mansion House, as well as more than sixty downtown buildings. It was rebuilt, with its signature cupola,[131] and thrived. "The property grew into the anchor of the downtown business district and included retail shops, a livery stable, a dining room, lodging—even the local weather station and telegraph office. The hotel was the hub of the neighborhood."[132]

Sherman and Susie Goldstein of West Tisbury have owned and managed the Mansion House since 1985. The heart and soul they have poured into the hotel shows in the elegant décor, the historic photographs and the comfortable atmosphere.

After a century and a quarter, a second fire in 2001 damaged the facility. Susan Goldstein recalled, "The volunteer fire department had never

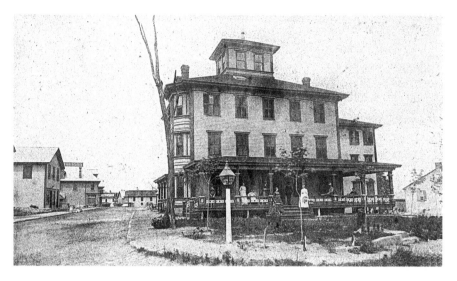

The Mansion House was rebuilt after the fire of 1883. The facility anchored the downtown district, as it does to this day. *Photos courtesy of Martha's Vineyard Antique Photos.*

fought a blaze of that magnitude, and some of the firefighters were wearing tuxedos, as it was the same night as a well-attended holiday party! All the down island towns' fire departments were called in, and the collaboration and skill to fight and conquer the blaze were remarkable." She added that the inn was completely rebuilt and the Goldsteins "upgraded all amenities, added an elevator and moved the inn from the eighteenth century into the twenty-first without losing the charm."[133]

"Each January locals know they can enjoy a 'staycation' at Mansion House Inn," says Susan Goldstein.

In 2016, all inn guest rooms were thirty-one dollars per person in honor of thirty-one years on Main Street. Islanders who take advantage of this special enjoy all free inn amenities: health club, pool, steam, sauna, hot tub and morning coffee and pastries. You know you are a Vineyarder if you are here in January. It's so much fun to see your friends and neighbors enjoying an overnight at the inn.

MARTHA'S VINEYARD PLAYHOUSE

The Martha's Vineyard Playhouse stands proudly at what is colloquially known as "the gateway to the William Street Historic District" on Church

Street. The facility was built for $2,000 in 1833 on pastureland donated by Captain William Daggett. The original post-and-beam one-story structure was designated a Methodist meetinghouse and served as such for a dozen years.

Tisbury town meetings were held throughout the mid-1850s, when the facility was purchased as a public meetinghouse and renamed Capawock Hall. The structure was literally raised and a first floor tucked beneath that functioned as a "cross between a farmer's market and a craft/artisan market," according to playhouse artistic and executive director MJ Bruder Munafo. The building continued to meet the religious needs of the community. The Vineyard's first Episcopal Church service took place there on December 24, 1862, and an elaborate pipe organ was installed three years later. The hall hosted weddings and community suppers and functioned for forty years as the Episcopal church.

In 1884, bodies from the wreck of the steamship *City of Columbus* were laid out in Capawock Hall for identification, before being shipped on to Boston.

The great fire destroyed the Free Masons' building on Main Street in 1883, and a dozen years later, in 1895, the Masons purchased Capawock Hall.

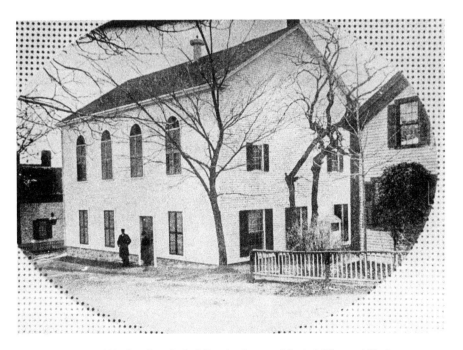

A quote from the 1890s describes the building that became Martha's Vineyard Playhouse as "one of the best suburban lodges in the state." *Courtesy of the Connie Sanborn collection.*

They remodeled it, converting the central meeting area into a lodge room, incorporating a balcony and installing electric lights. The first-floor banquet room featured an indoor toilet, a cloakroom and a smoking room.

The Masons operated the facility as a lodge for nearly a century. In 1982, Eileen Wilson and Isabella McKamy purchased the building to found a theater company. It became the home for the Martha's Vineyard Playhouse Company.

Today, Martha's Vineyard Playhouse is a professional, nonprofit theatrical company with a viable, variable production program. It serves "its role as one of Tisbury's cultural and architectural gems for future generations," according to the playhouse website.

The playhouse underwent extensive renovations in 2014, inspired by the facility's history, dating back to its construction in 1833. "Paul Munafo, the de facto Playhouse building manager, said, 'There is 181 years of history in this building. Our goal from the start has always been to preserve this building for another 181 years. What we have here is extremely important for Vineyard Haven. There is no other building like this in town.'"[134] Munafo has served the theater well, as carpenter, actor and builder of sets. His wife is MJ Bruder Munafo, the artistic and executive director of Martha's Vineyard Playhouse. Paul Munafo said, "We are constructing a modern, energy-efficient building while retaining and enhancing the historic details of the original."

The seating of the theater was reconfigured to improve audience accommodation and appreciation of the performances. The stage was dedicated as the Patricia Neal Stage to honor the actress who contributed so much to theatrical lore and the Vineyard experience.

THE STONE CHURCH

The Christ Methodist Center for Mission and Outreach, known as the United Methodist Church of Martha's Vineyard, or Stone Church, is at the corner of Church and William Streets in Vineyard Haven, across from its original site, now the Vineyard Playhouse. The original Methodist Episcopal Society was incorporated in 1833 and dedicated as the Methodist Meeting House.

A new meetinghouse, site of the present Stone Church, was built across the street in 1845. It cost $6,000 and was in keeping with colonial church architecture. It served the community as its predecessor across the street evolved from Methodist meetinghouse to the Vineyard Playhouse.[135]

This second Methodist meetinghouse thrived well into the twentieth century. The Vineyard Haven Band stored its instruments, music and the records in the church basement.

Records of the Vineyard Haven Band were destroyed when the church caught fire and burned in 1922. "The Band's early history had been passed on by word of mouth, from trumpet player to clarinetist, from father to son...[as] the Band's music and instruments burned in a New Year's Eve fire at the Christ Methodist Church in Vineyard Haven—along with what documents of its origins existed."[136]

It took a year and a half to rebuild the church, this time using stone "so it couldn't burn down," one of the parishioners observed. During reconstruction, worship services reconvened at the Masonic hall across the street, site of the original Methodist church. Herbert Hancock, secretary and treasurer of the church and the Woodbury and Stuart Construction Company,

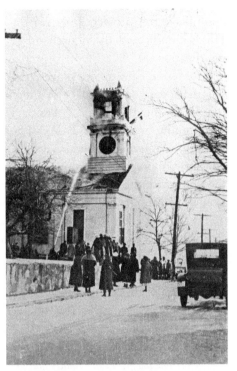

Top: The church was destroyed by fire early Sunday morning, December 31, 1922. Flames erupted when the church furnace overheated. *Courtesy of the Connie Sanborn collection.*

Right: The impressive stained-glass window of the Stone Church was repaired by local artisan Barney Zeitz. *Photo by Joyce Dresser.*

completed the project. Jim Norton did the stone work. Bishop Edwin Hughes dedicated the church on July 20, 1924. The new building cost nearly $60,000.[137]

The Stone Church has played a vibrant role in the community over the past half century. In 1976, Wintertide coffee shop came into existence, thanks to the diligence of Pastor Don Lyons from Martha's Vineyard Community Services and Pastors Leon and Helen Oliver of the Methodist Church. Wintertide offered a venue for local musicians to perform in a vibrant, supportive community. "Creative people seem to be drawn to the Vineyard, especially those who practice the musical arts," said Tony Lombardi, who managed Wintertide from 1988 to 1998.[138]

The Island Food Pantry began in the church in 1981, again thanks to Pastor Helen Oliver. Her statement read, in part:

> *Before the Food Cupboard* [original name] *started, there had been an increasing number of persons coming to our parsonage asking for food. I remember one group of three who said they had been "white knuckling" it. By this they meant that they had been trying their best to clench their fists and stave off hunger. They hated to ask for food, but, when their hunger became too great, they finally had to humble themselves and seek help.*[139]

The Food Cupboard evolved into the Island Food Pantry. Pam Perry succeeded Pastor Oliver in 1984; in 1996, Armen Hanjian was named coordinator and continues in that role today. Free food is available for those in need from November to April and at other times by appointment. Donations keep the pantry relatively well stocked, but items like coffee, juice and healthy foods can be in short supply.

Since 2010, the United Methodist Church also houses Clothes to Go, a program to receive "donations of new and 'gently used' wearables from generous Vineyarders and made them available free to those who need them," according to the *Martha's Vineyard Times*. Jennifer Wey Fiore, who initiated the program, "said she is glad to be next door to the Island Food Pantry to make it easier for patrons, and she has received invaluable support and advice from its director, the Reverend Armen Hanjian."[140]

Clothes to Go coordinates its schedule with the Island Food Pantry, making it convenient for both donors and recipients. "The $10 or $15 collected in a donation pitcher each week goes into the Trinity Methodist Church Sunday plate." Brenda Piland, of Clothes to Go, suggests that patrons wash the items they receive, "just to put your own spin on it."[141]

"People drop off donations often. That afternoon [that the reporter visited Clothes to Go] a woman brought several clean, colorful children's tee-shirts. While some donors give one or two items, others arrive with boxes or trash bags, stuffed to bursting. This winter, a community member came with a stack of warm blankets, quickly claimed by delighted patrons."[142]

Clothing turnover is high, especially as the weather turns chilly. Because the church is generous with its space, out-of-season donated clothing can be stored in the basement.

Local artisan Barney Zeitz repaired the imposing rose window of the Stone Church. "Even though the window looks beautiful the leading is bowed inward and several cracks have appeared. Complete re-leading and proper bracing with an appropriate breathing space around each panel will restore this window to perfect condition." He said, "I have ground the edges of every piece of glass to fit perfectly into a wider heart that has a channel in it for steel rods."[143] Zeitz completed the restoration of the Charles Connick rose window; once more it retains its original glory.[144]

CAPAWOCK AND WATERWORKS

Two recently renovated Tisbury structures are worthy of mention.

Capawock means "enclosed harbor" in the Wampanoag tongue. Capawock constitutes the harbor of Vineyard Haven. The Martha's Vineyard Playhouse building was once known as Capawock Hall. The Capawock movie theater is on Main Street and recently underwent extensive renovations to bring it into the twenty-first century in both décor and technological service. It is now operated by the Martha's Vineyard Film Society.

Another local facility is the Tisbury Waterworks, on the shore of Lake Tashmoo. In the late 1880s, this pumping station was built to provide water to downtown, with a steam-powered engine, the first on the Vineyard. In 1905, the town expanded its capacity and replaced it with electricity in 1919.

The risk of salt water breaching the shoreline of Lake Tashmoo increased with the hurricanes of 1932, 1944 and 1954. The last storm, Hurricane Carol, damaged the equipment, although pumping operations continued until 1971. The building fell into disuse yet was renovated and reopened as a function center in 2014. Today, it is an example of adapting the past for present purposes.

After World War II, the airport tank was removed and converted into a private home on Hines Point: a water tank with a water view. *Photo courtesy of Herb Foster.*

WEST TISBURY: CHRISTIANTOWN MEMORIAL

The tiny Christiantown Memorial chapel is the only structure still extant from the effort to convert local Wampanoag to Christianity in the seventeenth and eighteenth centuries. The current church, built in 1829, replaces a previous structure that burned. With its tiny altar and fifteen pews, it served for decades as a meeting place for Native Americans in what became known as Christiantown.

An agreement was signed by Thomas Mayhew Sr. and Sachem Keteanummin, known as Josias, in 1670. The treaty stated that the square mile of land in Manitouwattootan, or Takemmy, the area known as Christiantown, "shall remain forever in the possession of the praying Indians." While it was a noble effort, Native Americans were forced from their land over the years.

A large plaque, commissioned by the Daughters of the American Revolution in 1910, commemorates the "praying Indians" and recognized

The Mayhew Chapel has not been used for over thirty years. It is owned and maintained by the Wampanoag Tribe of Gay Head/Aquinnah. *Photo by Joyce Dresser.*

"the services of Governor Thomas Mayhew and his descendant missionaries who here labored among the native Indians."[145]

Adjacent to the chapel is a Martha's Vineyard Land Bank property with a short, circuitous walk. In 1986, it was "acquired so that the background of the Christiantown chapel would not be spoiled by houses." The Land Bank encourages the property to be used for "nature study, hiking, picnicking, mountain-biking, horseback-riding, dog-walking." In the 1980s, Christiantown was awarded special recognition by the state Office of Energy and Environmental Affairs. Across from the chapel is the Christiantown cemetery.

Efforts to renovate and repair the chapel have been undertaken numerous times over the last century. The Wampanoag Tribe of Gay Head (Aquinnah) assumed ownership of the tiny structure in 1993 and established a Christiantown committee to maintain the site. The Wampanoag repaired the roof, but the building has since slid into a gradual decline. "Today the weight of history is more apparent than ever in its moss-covered roof, peeling white paint and crumbling ceiling. A peek through the windows reveals 15 small, tidy pews, a small wooden altar and a large pile of broken plaster."[146]

Bettina Washington, Wampanoag tribal historic preservation officer, confirmed to the *Gazette* that the building had not been used recently.

"Christiantown was a sacred site to begin with," she said. "It was significant before it was a Christian place." Missionaries would "exert influence over native communities by destroying sites of traditional importance, or taking them over for other purposes. The site's original name, Manitouwattootan, translates roughly to 'the place of spirits.'" When the chapel was open to the public, Wenonah Madison would lecture on Wampanoag history. On occasion, small weddings were held at the chapel.

Letters to the editor reflect curiosity and concern on the chapel's preservation: "We were married at the chapel on Sept. 19, 1970, still going strong. Request info on how we can donate to the foundation or group responsible for the renovation and restoration. Thank you. René & Karen Hebert." And:

> *On my last visit to the Vineyard, in September, I was shocked at the condition of the Mayhew Chapel in Christiantown: windows broken, exterior shingles rotting, bird droppings on benches inside, weeds taking over the burial ground. My question is: Does anyone have a plan for repairs? I have been told repairs are usually done with a government grant, but if there is none, why couldn't a handyman with a few hundred dollars shore the place up? Vivian Pacewicz.*

GRANGE HALL

In 1858, the newly formed Martha's Vineyard Agricultural Society purchased three acres of land in West Tisbury to construct a building for its agricultural fair. The building was completed the next year. The chosen site is central on the Vineyard, amid the farming community of West Tisbury. For nearly 150 years, the Grange Hall served as the site for the annual Agricultural Fair, held in October, at the end of the growing season.

In 1995, the Agricultural Society built a new building—or, actually, bought a New Hampshire barn and relocated and raised it on Panhandle Road. Shortly thereafter, in 1997, the Grange Hall was sold to the Preservation Trust, an organization that preserves and protects historic island properties. The trust restored the building so that, today, "this grand post and beam barn stands as an enduring landmark, the site of a variety of traditional Island activities such as farmers markets, artisans fairs and antiques sales."[147]

The Grange Hall is on State Road, easily identified by the date of construction on the front. The facility has a capacity of 150 people and is often rented out for private or community events. The commercial kitchen on the first floor is available to prepare food; the second floor has a theater.

For nearly twenty years, the Martha's Vineyard Artisans Festival has been held at the Grange Hall. All summer long, the Artisans Festival gathers, both inside and outside the hall. There is no charge for parking or admission, and the facility is adjacent to the playground behind town hall.

The artisans offer a weekly juried art show where dozens of artists present their work. According to its website, there are "many demonstrations, weaving, fine furniture, pottery, stained glass, oil paintings, pastels, mixed media, sculpture, wampum jewelry, quilts, clothing, sea glass windows, handmade books and much more."

The Grange Hall also hosts antique shows, musical events and guest lectures and serves as a community gathering site.

Another popular program at the Grange Hall is the farmer's market, held twice weekly in the summer. It relocates to the new Ag Hall in the fall. The farmer's market "is dedicated to bringing local agricultural products to the people both living on and visiting the island." Begun in 1974 with a dozen farmers, now nearly forty farmers promote their produce. The farmer's market draws a considerable crowd in the summer, with music, vegetables, crafts and edibles. The market is on the grounds of the Grange, not within the historic structure.

CHILMARK: QUANSOO HOUSE

Sheriff's Meadow Foundation received a gift of the Quansoo Farm, including the Mayhew-Hancock-Mitchell House, from the late Florence B. "Flipper" Harris in 2007. The house may well be the oldest on Martha's Vineyard in its original location. Sheriff's Meadow plans to restore the house for posterity and provide educational opportunities for schoolchildren.

The Sheriff's Meadow website states: "The house was likely built here because of the rich natural resources of this area. Quansoo offers access to a wealth of eels, clams, oysters, crabs, fish and waterfowl. Also, much of the soil of Quansoo Farm is considered prime soil for farming. Sheriff's Meadow Foundation is restoring the historic house [to] continue the farming heritage of this land."

The house is a historic treasure. "This is only one of four such structures still standing in the nation. That makes it significant," said Adam Moore, executive director of Sheriff's Meadow.[148] The four oldest houses are all in Massachusetts, with walls of wattle and daub. Wattle is strips of oak squeezed between posts to form a lattice; the interior is stuffed with daub, which combines straw, clay and sheep dung.

"The front room, southeast room, is probably the oldest part of the house. That's where you can see the wattle and daub. There was a room added to the rear and to the side of that. Then there was another section added on the eastern part of the house. And finally, in the 1800s, there was a section added on to the rear," Moore told Mike Seccombe of the *Gazette* in 2010.[149]

Three years later, efforts were underway to restore the Mayhew-Hancock-Mitchell House and, in the process, determine its age, based on tree rings. Another *Gazette* reporter, Remy Tumin, spoke with an expert in dendrochronology, the study of dating structures by tree rings. "When I core it I know that I got the last year of growth and the year they took the tree down, which usually means the following year was the earliest they could frame it," the dendrochronologist said. Trees were cut in the winter and used to frame houses in the spring. Unfortunately, the beams had decayed so the outer growth rings were nonexistent. The beams have since been replaced as part of the restoration project.

The house is made up of sitting rooms, a borning room (near the fireplace, where a woman would deliver her baby) and a buttery. Peeling back wallpaper, which likely came from England, and removing wood paneling revealed the wattle and daub beneath. Decorative exposed beams, known as chamfering, a seventeenth-century technique, had been carved in the slanted ceilings. Hand-cut floorboards and wrought-iron nails corroborate the authenticity of early American construction.

The Mayhew-Hancock-Mitchell House was a farmhouse. Sheriff's Meadow intends to return it to its agricultural heritage and thus preserve the rural charm of the farm. And the foundation seeks to list the house in the National Register of Historic Places.

Once the house is restored, plans call for it to be used for meetings, educational programs and other activities. "Restoration work will include encasing portions of exposed wall, for example, to showcase the unique construction," reported the *Gazette*. "The nicest thing we'll get to do with this house is the educational elements to it because the children grasp all of it," Moore told Tumin in 2013.[150]

A third *Gazette* reporter visited the Quansoo house in 2015: "The site resembles an archaeological dig as well as a construction site—and essentially it is both."[151] The eighteenth-century foundation had been exposed, studied and shored up. Replacement wooden sills were in place. Local lumber was used wherever possible.

Sheriff's Meadow originally dated the house to the mid-1600s; however, an archaeological study questioned that time frame. Historian and archaeologist Myron Stachiw performed an assessment of the archaeology of the building, known as a forensic architectural history. "'The big surprise was that the house was probably constructed somewhere between 1750 and 1770,' Stachiw said. 'The house also was built somewhere else before being moved to its present site in the late 1790s.'"[152]

Not everyone agrees. "To begin with, I do not believe the house was moved, as claimed, for a number of reasons," wrote architectural historian Jonathan Scott. "You cannot move a clay wall without destroying it, and the wattle and daub in the front room is in perfect shape. The house sits only a few inches off the ground on a 17th century rough stone foundation with an ancient cellar beneath the southwest room. Framing for several casement windows, which commonly were imported from England in the 17th century when glass was scarce." He concluded, "I am certain this is a genuine 17th century house."[153]

The age of the house is still in question. "What is clear is that a New Bedford newspaper from 1837 was found in the rear ell of the house, the 'newer' section," said Adam Moore. "A debate still flourishes on the front of the house, and dendrochronology is underway. No other house on the Vineyard has used a comparable dating method. The oak trees that framed the Quansoo house were unique. Now two other Vineyard houses have been sampled, so conclusive comparative date may be realized."

Executive director Adam Moore confirmed that Sheriff's Meadow "intends to invite school groups to the house, and we plan to create an educational program oriented specifically to the house."[154] School groups have already visited the house. Another goal is to offer an agricultural program at Quansoo Farm. The work at the Quansoo House continues. As Moore stated, "Our hope is that the house will be open to the public in the summer of 2017. There will always be work on the house, but by then, the chimney and landscaping should be completed."

DUTCHER DOCK

"I think it is time for my annual tutorial about Dutcher Dock," wrote *Gazette* columnist Jane Slater in 2010.

> *Rodney Dutcher, who died in 1938, was a distinguished journalist, a friend of President Franklin Delano Roosevelt and well respected in Washington. He was a yachtsman who enjoyed coming to Menemsha. When the 1938 hurricane devastated the Menemsha harbor, he started a private fund to help the fishermen. The extension of the bulkhead dock, from the gas station to the jetty, was dedicated as Dutcher Dock in 1941. The dock from the charter boats to the gas station is called the Bulkhead Dock. The dock space called Dutcher Dock is used by yachtsmen to this day and the Bulkhead Dock is reserved for the commercial fishermen. Menemsha is grateful for the kindness of Rodney Dutcher. His grave is at Abel's Hill cemetery and a bronze plaque tells of Franklin Delano Roosevelt's regard for him.* [155]

Rodney Dutcher wrote a newspaper column syndicated in five hundred newspapers. This monument to him is at Abel's Hill cemetery. *Photo by Thomas Dresser.*

Prior to accurate forecasting, the hurricane of 1938 struck Martha's Vineyard on its path up the Eastern Seaboard on September 21, 1938. It devastated a good part of the shoreline and caused extensive damage to the tiny harbor of Menemsha, on the southwest shore of the Vineyard.

"Journalist Rodney Dutcher witnessed the devastation," wrote Tom Dunlop. "Dutcher, born in Oak Bluffs in 1901, had moved off-Island in 1910, but returned on infrequent yachting vacations from his job as a journalist during the presidency of Franklin Roosevelt. Dutcher recognized the enormity of the disaster, and the impact it would have on the little fishing village of Menemsha."[156] Dunlop noted, "His influence could be felt far beyond Martha's Vineyard." The story continues: "Shortly after the storm, he wrote a column about the destruction of the village and began to call the undersecretaries, commissioners, and directors who could most effectively organize a rebuilding program and direct federal money to the effort."

While the movement to rebuild the harbor was in its nascent stage, Rodney Dutcher suffered a heart attack and died in November, months after the hurricane. Perhaps it was his early death (he was only thirty-seven), his "great charm as a host" or his close affiliation with President Roosevelt that spurred government agencies and private funds to be raised to repair the harbor.

It was not until August 22, 1941, that the recreational pier was completed and dedicated to Rodney Dutcher. Officials from Washington and Governor Leverett Saltonstall participated in the fanfare. "The town turned out with flags, bands, selectmen, and the citizenry dressed in their Sunday best to extol Rodney Dutcher: He was the man on the scene during the storm who, with his column and connections, had set everything in motion in the weeks before his unexpected death."[157]

In a letter to the editor of the *Martha's Vineyard Times*, Harriette Poole Otteson sought to clarify the name of Dutcher Dock.

> *How many years and Letters to the Editor will it take to educate the wash-ashores that the dock pictured in the* MV Times, *April 9, on page A13 (Vineyard Gallery), is not "Dutcher's Dock"? The dock pictured is, and always has been, the bulkhead. Dutcher (no -'s) Dock extends from the Menemsha gas station west to the end of the parking lot. Rodney Dutcher, Vineyard son and New York/Washington newsman, observed the destruction at Menemsha during the 1938 hurricane. He immediately set up a fund to build the dock extension for visiting boaters. On August 22,*

1941, Dutcher Dock was dedicated with much ceremony, with the governor, state and town officials, and Chilmarkers in attendance. Unfortunately, Mr. Dutcher did not live to see the dock completed. His wife saw it through to completion. Harriette Poole Ottesen.[158]

AQUINNAH: BAPTIST CHURCH

The Community Baptist Church of Gay Head was constituted in 1693, making it the oldest Native American Baptist Church in North America.[159] The church was the first Christian gathering place of the Wampanoag. In 1698, the wood-framed building was built on Old South Road, adjacent to a burial ground.

When State Road was built through to Gay Head, now Aquinnah, in 1850, the church was moved up the hill by teams of oxen. The church was rebuilt on its present site on Church Street, near the center of town. "When the new church was being built, the rafters from the former were taken by ox teams to be used for another house. The folks living in this house were said to sometimes hear natives singing hymns of praise."[160] The Wampanoag Tribe website notes, "The pews, which are one piece of solid wood, have been used for the past 150 years."

The church functions in conjunction with the First Baptist Church in Vineyard Haven; on occasion, the two congregations gather together for worship. In the off-season, the Bible study group meets in private homes.

The background of the conversion of the church from Congregational to Baptist is convoluted. "The Baptist congregation in Aquinnah is the oldest church on Martha's Vineyard. The ministry was begun by Thomas Mayhew Jr. and his father, Governor Thomas Mayhew Sr. The Mayhews were Congregationalists, but sometime around 1693, the Aquinnah congregation became Baptist."[161]

An expert on the early colonial era, historian David Silverman, posited in his 2005 book, *Faith and Boundaries*, that the switch from Congregational to Baptist may have been political rather than religious. The Mayhews sought to replace a deceased Wampanoag minister with the grandson of Thomas Mayhew, Experience Mayhew; however, the Native Americans preferred one of their own. Their church was a meeting place where the Wampanoag could speak with one another in their own language, a sacred language, and not feel the imprint of the Englishmen.

The congregation of the Community Baptist Church is small and without musical accompaniment. *Photo by Joyce Dresser.*

"Not willing to have an Englishman, even a Mayhew, for their pastor, they joined a different sect. Now, 318 years later, the Aquinnah Baptist church is the oldest continuously operating Native American protestant congregation in the country."[162] Standing up for their language, and a pastor of their own, brought legitimacy to the Wampanoag, at least in their church.

GAY HEAD LIGHT

The Gay Head lighthouse was initially proposed to warn ships of the dangerous waters off the promontory of the Gay Head Cliffs, where Vineyard Sound washes around the cliffs. Devil's Bridge—a great glacial rock, or erratic—is just off shore, underwater.

President John Adams approved the petition for a lighthouse in 1799, and a wooden structure was built. It stood forty-seven feet high, and its whale oil lamp warned ships of the dangerous peninsula. In 1844, the wooden lighthouse was moved seventy-five feet back from the eroding cliffs.

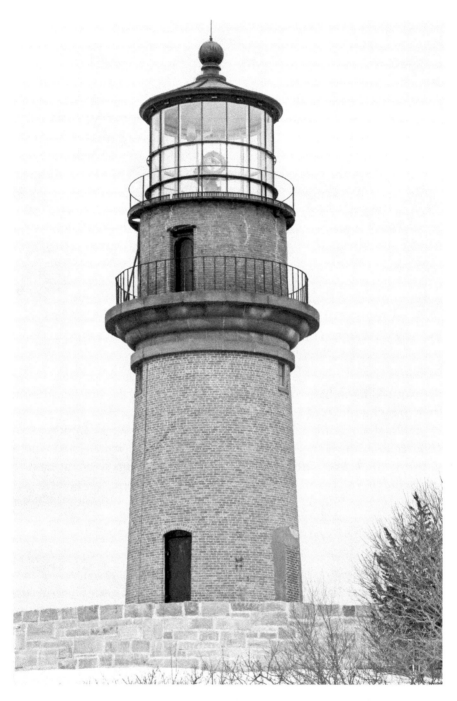

Greased by Ivory soap, the Gay Head lighthouse was eased down a track, a distance of 129 feet, over a few short days in May 2015. *Photo by Joyce Dresser.*

This octagonal building survived until the 1850s, when it was determined a stronger base and brighter light were required. A new lighthouse was built of brick, made right on the Vineyard, just a few miles away. The brownstone balcony was cut in a Connecticut quarry, and the wrought-iron railing was installed. The light was a first-order Fresnel lens, manufactured in and sent from England, hauled twenty miles from Edgartown by a team of eight oxen over dirt-packed roadways. Mirrors from the whale oil lamp reflected twenty miles out to sea.

The red brick lighthouse went into service in 1856, and the old wooden one was dismantled. In 1885, kerosene replaced whale oil in the lamp. The lighthouse was whitewashed around the turn of the century and, along with the keeper's cottage, painted red about 1903. A brick lookout tower adjacent to the lighthouse was erected during World War II to scan the waters for submarines. Running water and electricity reached the Gay Head Light in 1953; it was automated in 1956.

The Coast Guard determined the Gay Head Light, as well as the East Chop and Edgartown lighthouses, should be decommissioned in the 1980s. William Waterway Marks, who organized the Vineyard Environmental Research Institute, or VERI, testified in Congress regarding the role his group could play in assuming control of the lighthouses: "We will be fully responsible for the maintenance of the structure. As far as the aid to navigation is concerned, that will remain with the Coast Guard."[163] VERI licensed the three lighthouses in 1986 and transferred them to the Martha's Vineyard Museum in 1994.

Richard Skidmore and Joan LaLecheur have served as light keepers of the Gay Head Light since 1990. They are hospitable and knowledgeable hosts of the lighthouse. President Obama visited the famed lighthouse with his family in 2009.

By 2013, the clay cliffs around the lighthouse had eroded to the point that the lighthouse was in danger of tumbling down to the sea. An effort was made by the Town of Aquinnah to purchase the structure and move the four-hundred-ton edifice back from the receding shoreline. It required thirty months of planning and cost more than $3 million, but the lighthouse was moved 129 feet back from the eroding cliff in May 2015.

Today, the Gay Head Light shines on. It is open to the public in season and managed by the Martha's Vineyard Museum.

AQUINNAH PUBLIC LIBRARY

The Aquinnah Public Library has a storied past, appropriate for its function as a repository for books. Initially, it was a schoolhouse.

The original Gay Head School was built in 1827 and enlarged to its present size in 1857.[164] Until 1968, Gay Headers attended school for grades one through six and then were bused down to West Tisbury. The two doors in front allowed boys and girls to enter the school separately. A comparable nineteenth-century schoolhouse in Chilmark now serves as the local police department. It, too, has two front doors originally meant to keep the sexes apart.

Townspeople paid for the operation of the school prior to the state's taking on that role. And in 1901, the Massachusetts state legislature established the Gay Head Public Library to function within the schoolhouse, granting sufficient funds to buy books. "For over thirty years, until her death in 1964, Ruth Jeffers worked hard to coordinate school and library activity and to involve the growing summer community of visitors."[165]

For years, the library was the only public meeting place in the community; indeed, until 1929, it was the only public building in Gay Head. That year, the town hall was erected across the road. "From earliest times, the Gay Head School/Library has been a meeting place for townspeople (regulated only by a sometimes inadequate supply of coal for the stove) and has always played a central role in the social and emotional fabric of the community."[166]

The library and town hall developed a symbiotic relationship through the years. Depending on the needs of the school, the wishes of the library and availability of storage space at town hall, the library "has been relocated to the town hall building, moved back to the schoolhouse, refurbished, moved back to town hall, flooded, returned to the schoolhouse, seen the addition of a front porch (while it was again in the town hall), and refurbished once again."[167]

The building has retained its original charm. "Except for the addition of modern plumbing, the removal of a bell tower, and a progression of heating systems, the building has remained much as it was originally conceived. It is currently the centerpiece to the historic town center district that is listed in the National Historic Register," according to the library website. It embodies the historic aspect it served as the heart of Aquinnah. Former head librarian Cathy Thompson said, "We're sort of like a community gathering place and a reading room combined."[168]

The school closed in 1968, but the library continues.

In 1936, the library achieved prominence due to the number of books circulated in proportion to the population of the community. The current

Built on the Old South Road before 1844, the Gay Head School was moved when State Road was constructed in the 1850s. *Photo by Joyce Dresser.*

collection boasts more than eight thousand books and is linked to the Cape Libraries Automated Materials Sharing (CLAMS) system. Nearly twelve thousand items were checked out in 2012.

Two other old schoolhouses still extant, besides the Chilmark and Aquinnah buildings, are a house on North Road that served as a school and another on Indian Hill Road. Both have their original school bells. The Lambert's Cove School, built about 1890, was across from the Lambert's Cove Methodist Church. It was used for nearly fifty years; in 1940, it was moved to Midland Avenue in Vineyard Haven. Another schoolhouse, now a private home, is on the Tisbury–West Tisbury town line on Lambert's Cove Road. In West Tisbury, the current town hall is the former West Tisbury school. And in Oak Bluffs the old elementary school is now town hall; across the street, the former high school is owned by the Catholic church.

VINEYARD GRAVEYARDS

When we peek within the confines of the cemeteries of Martha's Vineyard, we are struck by the number of graveyards, the variety of tombstones and the prominent people buried in the fields and hillsides across the island.

Exploring a cemetery yields cultural aspects about a community. Tracing the history of the stones, from the earliest to the more recent, shows the evolution of how a life is remembered. "Cemeteries are where ordinary people put things they want remembered by history, such as themselves."[169]

In our early history, the ornamentation of the stones was somber and stoic. That sense of doom lifted as time and culture contemplated the possibility of redemption. Military memorials recognize service by a soldier to his country. You cannot draw strict conclusions about graveyards in general or make generalizations about the Vineyard in particular. However, scanning tombstones across the island allows us to appreciate the variety in memorials and graves hidden in our midst.

Stories within the cemeteries of Martha's Vineyard lie in the people entombed, whether they are prominent Vineyarders with long, entangled genealogical roots or everyday people, washashores who found everlasting repose on the Vineyard.

More than thirty burial sites are scattered across the Vineyard, from humble Native American graves to the staunch vaults of colonial citizenry. We will peruse several monuments, unique gravestones, unusual carvings and commemorative stones. We respect the graves of Wampanoag Native

Americans across the Vineyard, and we categorize cemeteries by town. This section is an overview of the variety of Vineyard memorials, hidden graves and graveyards. It may serve as a steppingstone for further research.

Common practice in the colonial era of the seventeenth and eighteenth centuries was "to bury the dead in churchyards located in close proximity to churches. Many 17th century New England towns set aside land as common community burial grounds. Headstone images from this period also reflect the rejection of formal Christian iconography in favor of more secular figures, such as skulls representing fate common to all men."[170] Thus, colonial cemeteries were nestled in the shadow of churches. Cemeteries were adjacent to a main thoroughfare, as access to the graves of forbears was important to pay respect.

Three primary designs appear on early New England slate tombstones: death's heads, cherubs and the urn and willow.[171] These varied designs reveal the "effect of off-Island influence on the religious values of the times."[172] Gravestones not only yield historical recognition but also offer an artistic vista of lives from long ago.

Gravestones in the oldest Vineyard cemeteries featured the death's head, denoted by a winged skull. The death's head was a graphic reminder of death and resurrection and the mortality of man. The grave of John Mayhew (1688) in West Tisbury featured erotic symbolism with breasts denoting divine milk to nourish the soul. Floral designs promised a heavenly setting, and an hourglass symbolized the passage of time. A preponderance of skulls and crossbones was common in colonial gravestones.

Many early stones were the work of Boston carver John Homer. The Lamson family carvers of Charlestown cut deeply carved skulls. Stones were carved off-island and then shipped to the Vineyard. Carver Ebeneezer Soule of Plimpton (1710–1792) inscribed many Vineyard stones. A typical gravestone from the eighteenth century read, "Memento Mortis."

In the mid-eighteenth century, cherubs replaced the death's head. The cherub arose from the Great Awakening of the 1750s and was brought from England to the Vineyard via Boston. Cherubs celebrated the resurrection and the heavenly reward in death. This belief gained prominence between 1760 and 1780.

Cherubs were personalized, with a human face and perhaps wings. The earliest cherub is in West Tisbury and "may represent attempts at portraiture of the deceased." Cherubs adorn the gravestones of high-status individuals. "The introduction of the Cherub motif to the Island was most probably by way of sea lanes from Boston to the Island."[173] The James Allen stone (1714)

in West Tisbury combines death's head with a cherub. And in Chilmark, the grave of Joseph Mayhew (1782), chief judge of Dukes County, is adorned with a cherub.

The cherub became so stylized it appeared mass produced. As the cherub design evolved, bodies were attached to the head, with teardrops by the face. Wings sprouted from the forehead, and then an oval smiling face, oval eyes and curled hair were added. A Medusa style evolved as well. These "occur throughout southeastern Massachusetts and Cape Cod and are exclusively marking the graves of infants or children."[174]

Gradually, the cherub style was replaced by the urn and willow, found first in Chilmark in 1770 and popularized across the island by 1796. The urn and willow arose in response to the intellectual perception of death, less emotional, following Unitarian Universalist religion. The design featured the outline of a willow with drooping feathers and a ribbed urn, later a circular urn. The majority of graves between 1800 and 1809 feature a single urn; most gravestones between 1810 and 1819 boast a single willow. The most elaborate urn and willow grave is Polly Manter's (1817) in the West Tisbury cemetery.

Sun and rays and orbs succeeded urn and willow. As James Richardson pointed out, "The study of tombstones is providing the anthropologist with a wealth of information concerning the processes of cultural change as evidenced in the changing design patterns through time."[175] The evolution of popular gravestone carvings illustrates the changes in attitude and beliefs of our ancestors. In this era, carvers rarely signed their stones.

The eighteenth-century Enlightenment inspired the Rural Cemetery Movement, initially at the Mount Auburn Cemetery in Cambridge. The movement arose in the belief that nature and art transcend the sorrow and sadness of death. The Massachusetts Horticultural Society formulated designs for rural parks in 1831, along rolling hills with rural vistas and viewpoints. The transition to cemeteries was a natural integration of the hereafter with the beauty of rolling vistas. Rural landscapes generated public parkways, popularized later in the nineteenth century by Frederick Law Olmsted's Emerald Necklace in Boston and Robert Morris Copeland's greenswards, broad avenues and numerous parks in Oak Bluffs.

So where did the stones for all these graves originate? Slate had to be imported to the Vineyard, as there is no slate on-island. The earliest stones were imported from England, probably from Wales. Carving was done off-island, usually in the Greater Boston area.

West Tisbury Cemetery superintendent John Alley explained, "Slate stone dates from about the 1690s. When water gets into cracks in the stone

and freezes, the slate splits over time. Great pieces fall away. Someone figured out how to cure that problem. They took strips of lead and protected the top of the stone with a little sloping roof."[176]

Lead was required for the manufacture of munitions in World War II. Scrap drives collected lead, so the slate stones were stripped of their shields. The result is that many stones are now damaged.

A memorial to Thomas Mayhew Jr. sits at Place by the Wayside, on the Edgartown–West Tisbury Road, near the entrance to the airport. The Daughters of the American Revolution installed it in 1901. The site dates to 1657, when Thomas Mayhew Jr., son of the progenitor of the Mayhew name, preached his last sermon before he prepared to sail to England. His ship was lost at sea, and Native Americans mourned his death. Whenever they passed this site, they left a small stone, a token of their respect for this missionary to the Wampanoag.

More than a century ago, historian Charles Banks concluded the first volume of his three-volume *History of Martha's Vineyard* with an assessment of how much life had changed in the previous two centuries:

> *If Squire Benjamin Skiff of Chilmark, a good representative of his time, who died in 1717, could come back to earth and see us in our present day environment, with our electric lights, trolley cars, automobiles, steamboats, daily papers, bicycles, Sunday excursions, telephones and telegraphs, and all the other accompaniments of our modern life, doubtless he would hurry back to the gloom of his tomb on Abel's Hill, and piously explain, "From the pomps and vanities of this wicked world, Good Lord deliver me!"*[177]

And with all the changes, improvements and contrivances of today, these words resonate once more.

EDGARTOWN

Edgartown hosts four town cemeteries, each with its own unique style, charm, beauty and historical significance.

The first burials at Pease Point Way Cemetery were six men who drowned off Gay Head in 1782. Also known as Old Westside Cemetery, it has 998 graves and is not accepting more. The New Westside Cemetery, established

This hearse was given by Mary Jernegan to the town of Edgartown in 1836. It continued service on Chappaquiddick into the 1930s. *Photo by Joyce Dresser; courtesy of Martha's Vineyard Museum.*

in 1949, on nearby Robinson Road is an extension to the Old Westside Cemetery and accepts new interments.

North Neck Road Cemetery, or First Cemetery, on Chappaquiddick, has five graves: Reverend Joseph Babcock Amos (1806–1869); Sophronia Sams Amos (1831–unknown); Jane Sanders Sammon (1753–1853), who lived to be one hundred; Jane Sams (1796–unknown); and Joseph Sams (1803–unknown).

The Old Burying Ground, also known as the Old Town Cemetery, Tower Hill or Green Hollow Cemetery, is on Tower Hill Road, off Katama Road, and has 152 graves, including many from the Revolutionary War era. The oldest grave in Edgartown, John Coffin (1711), is at the Old Burying Ground.

Jeffer's Lane Cemetery, also known as Indian Burial Ground, Indian Cemetery or Hilltop Cemetery, is on Chappaquiddick, overlooking Cape Pogue Pond, surrounded by conservation land. "This cemetery contains both marked and unmarked graves of the Chappaquiddick Wampanoag tribe. The predominantly unmarked graves of the Chappaquiddick Wampanoag tribe occupy the center of the cemetery."[178] Author Vance Packard (1914–1996) has a stone here, but his ashes were scattered elsewhere.

This cemetery was originally part of the Chappaquiddick Indian Plantation, later owned by the Belain family. Ten gravestones are illegible but may belong to the Belains. Jeffer's Lane is on ancestral lands of the Chappaquiddick tribe of the Wampanoag Nation and was opened to locals under the Massachusetts Act to Enfranchise Indians of 1869. "The Chappaquiddick Wampanoag believe that field stones in the cemetery mark the burials of their ancestors from an earlier time."[179]

Inscribed gravestones at the Chappaquiddick Burial Ground include Wampanoag graves. Sarah (Brown) Martin and her husband, William A. Martin, are buried there. Martin, the great-grandson of the slave Rebecca, was the first and only African American whaling captain on Martha's Vineyard. His wife was a member of the Chappaquiddick tribe.

Ancestors of Diane Durawa are buried in a tiny cemetery in Tom's Neck, Chappaquiddick. And Casey Reagan, who searches out lost Vineyard graveyards, suggests there's a grave along Meshacket Road, also in Edgartown. These little lonely graveyards link us to a past when it was common to keep loved ones nearby.

OAK BLUFFS

Eastville Cemetery is adjacent to the Lobster Hatchery, on Shirley Avenue, the site of the original Marine Hospital, which operated from 1798 to 1824. Graves there are likely sailors served by the hospital.

Farm Neck Cemetery, off County Road, contains two dozen graves. It is primarily a Native American burial ground, as several stones bear no inscriptions. Of the carved gravestones, the earliest recorded burial is 1764.

On Barnes Road, the Smith family cemetery has five graves, the earliest that of Thomas Smith, dated 1831. Elisha Smith (1845–1863), a Vineyard volunteer in the Civil War, died after the Battle of Gettysburg. *Seen the Glory* by John Hough recounts his wartime experience. Three recent interments complete the roster.

An intriguing stone sits beyond the corner of County Road and Edgartown–Vineyard Haven Road. As the *Vineyard Gazette* explained:

> *The small burial plot, an enclosure with a single headstone, near Dodgers Hole on the Edgartown–Vineyard Haven Road, is passed by countless unnoticing motorists every year. Yet it is a landmark with a certain lonely mystery and, once reminded, most Vineyarders recall it well.*

Eastville Cemetery, at the end of Shirley Avenue, was reclaimed by high school students in the 1990s searching for graves of African Americans. *Photo by Joyce Dresser.*

"The story tells of the migration of one of the Island Norton families to northern Maine. A member of the family was Sarah, buried here." From the *Vineyard Gazette* of November 3, 1967. *Photo by Joyce Dresser.*

The history of the place is meager and the oldest Islanders can only guess who might have been who took such pains to enclose it, building the low wall with care, finishing off the gateway with cut stone posts which once bore chains to prevent animals from entering, as the rusted eyebolts in the posts testify.

She [Sarah Norton] *married Joseph Wilbur, described as a giant of a man. It was said that she wanted to be buried at this spot which then commanded a distant view of the church spires of Edgartown, and that her husband ordered that his grave should be dug on the eastern side of hers and "mounded high" so that she might not see the spires after all.*[180]

Even in death a vindictive husband got his way, or so it seems.

Another family graveyard belonged to the Luce family and is located in Iron Hill Farm.

The primary cemetery in town is Oak Grove, on Pacific Avenue, which holds 260 graves, the earliest from 1759. Oak Bluffs and Vineyard Haven both have an Oak Grove Cemetery.

Dorothy West was part of the Harlem Renaissance and wrote prodigiously throughout her long life. Her columns in the *Vineyard Gazette* were legendary. *Photo by Joyce Dresser.*

Dorothy West was a prominent Oak Bluffs woman, a participant in the Harlem Renaissance, the author of two poignant novels and myriad short stories, a newspaper columnist and an integral part of the Cottagers Inc., a philanthropic organization of African American women, founded in 1956. "Dorothy West's cremains are buried in the Jordan plot at 105 Hemlock Avenue. It is to the right off Evergreen Avenue which is the entrance road opposite the Library."[181]

Sacred Heart Cemetery is located adjacent to Oak Grove with sixty-eight graves, the earliest dating from 1902. The Roman Catholic Diocese of Fall River oversees this cemetery.

VINEYARD HAVEN

Crossways Cemetery, the oldest cemetery in town, has 235 graves. It is also known as the Causeway Street Cemetery, South End Cemetery, East Village Cemetery and Company Place Cemetery, but it was originally the Chase Family Cemetery, a private burial ground for the family of Abraham Chase.

Seaman's Friend Society Cemetery is off Canterbury Lane, Vineyard Haven. Each of the seventy-two graves is marked by a stark wooden stake. *Photo by Joyce Dresser.*

Seth Daggett (died 1779) and his wife, Elizabeth West (died 1807), are buried in a thicket overlooking the head of Tashmoo. He died of "the smallpox." *Photo by Joyce Dresser.*

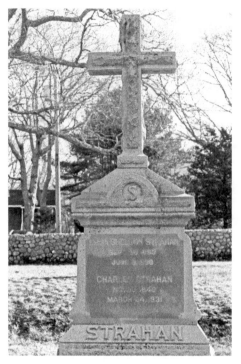

The cemetery was founded in 1719 and is owned by the Town of Tisbury. The oldest grave is Elizabeth Chase, 1719.[182] One of the three Liberty Pole ladies, Parnel Manter, is buried there.

Actress Katharine Cornell is buried in the Village Cemetery on Franklin Street. Founded in 1770, Village Cemetery has eighty-nine graves and is privately owned yet maintained by the town. The other two Liberty Pole ladies, Polly Daggett Hillman and Maria Allen, are buried there.

West Chop Cemetery on Main Street was established in 1791. Three prominent wordsmiths are interred in West Chop Cemetery: Art Buchwald (1925–2007), the humorist who wrote a syndicated column for the *Washington Post*; William Styron (1925–2006), the author of *Sophie's Choice*, a novel about a Holocaust survivor, and *The Confessions of Nat Turner*, which earned him a Pulitzer Prize; and Mike Wallace (1918– 2012), known for investigative

Top: The grave of Charles Strahan, (1840– 1931), who erected the Soldiers' Memorial Fountain, is in Oak Grove Cemetery in Tisbury. *Photo by Joyce Dresser.*

Left: The Martha's Vineyard Hebrew Cemetery is a private section of Oak Grove, along West Spring Street, Tisbury. *Photo by Joyce Dresser.*

journalism on *60 Minutes*. Wallace attended Brookline elementary school with John F. Kennedy. West Chop has seventy-four graves. And nearby, at the lower end of Daggett Avenue, lies a gravestone, flat in the ground, another relic from the past.

WEST TISBURY

John Alley has been West Tisbury Cemetery superintendent since 1982. When you ask him about the oldest grave in town, he reminds you, "Until 1892, we were part of Tisbury, but the oldest marker in West Tisbury dates back to 1670. It was a Mayhew."[183]

Once he gets started, there's no stopping him. "I can tell you this. The cemetery in West Tisbury was on the main road, which ran past Whiting's Farm, into the cemetery by the church and connected to Scotchman's Lane, where it crossed the bridge." That road led on to North Tisbury.

Alley is full of information about the cemetery and offers a wealth of amusing and intriguing stories:

"The church was in the middle of the cemetery, on a little rise. It was like an old English cemetery, with the gravestones all around," said John Alley. *Photo by Joyce Dresser.*

The church was moved in 1865 to its present location at the corner of State Road and Music Street, which was then the center of town. Originally there was a settlement in Deep Bottom, on the south shore, made up of houses and farms, but the population shifted up to the center and churches were always in the center of the population.

One time I was fixing a stone that had snapped, and we pulled it out of the ground. Turns out, the engraver made a mistake and misspelled the name of the deceased. So he turned the stone upside down and carved the name correctly, and set it in the ground. That was a first for me.

Old stones often have unique designs, scripture and figures to adorn them. On occasion, the stone bears an image relating to that person.

West Tisbury Cemetery, also called the Village Cemetery, has 640 graves with dates from the early 1700s. Martha Lumbert (1639–1698), born and baptized in Barnstable, married John (Manton) Manter in 1657. They had eight children. It is assumed she was buried in the Village Cemetery, according to local record; however, there is no gravestone.

According to historian Charles Banks, "There are not half a dozen gravestones now [1911] on the Vineyard which bear a date prior to 1700. The oldest stone is that marking the grave of Rev. John Mayhew in the West Tisbury cemetery, and is dated 1688."[184] Reverend Mayhew was the son of missionary Thomas Mayhew, grandson of the original Thomas Mayhew.

John Alley said, "In addition to the many farmers, the West Tisbury graveyard contains a handful of men who died in the Civil War and even one who died during the California gold rush."

The most prominent name of note is that of Nancy Luce (1811–1890). Nancy Luce was a nineteenth-century entrepreneur who lived a solitary life, writing poetry, preaching and caring for her beloved chickens. Today, her gravestone is festooned with small chicken statues. Fans from far away pay homage to this independent personality of the nineteenth century.

"Each cemetery has a different character," John Alley said. "It plays host to the families that originally settled into the towns."[185]

A pond lies alongside the Lambert's Cove Cemetery, just over the rise of the hill. It is a haven for lilies in the spring. The Lambert's Cove cemetery has 411 graves, the earliest dating to 1762.

"There is almost no end of the tales that might be told of the people who lived in Lambert's Cove," wrote a contributor to the *Dukes County Intelligencer*.[186] Prominent people buried in Lambert's Cove include Captain Nathan Smith, who led the seacoast defense for the Vineyard in the Revolution. He was

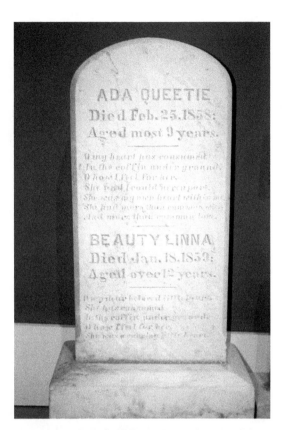

Right: Nancy Luce spent her hard-earned money to pay for a gravestone to memorialize two of her chickens. *Photo by Joyce Dresser; courtesy of the Martha's Vineyard Museum.*

Below: Lambert's Cove Cemetery is beyond the Methodist church. It is the quintessential rural cemetery. *Photo by Joyce Dresser.*

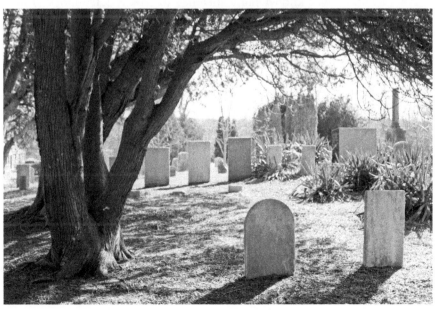

Graves are marked by headstones and footstones without inscriptions in the Christiantown Native American Cemetery of the Wampanoag Tribe of Gay Head/Aquinnah. *Photo by Joyce Dresser.*

known for "working the hummocks," marching his men back and forth to give the British the impression that his forces were much more numerous.

Another once well-known name belongs to Mildred Dunnock (1901–1991), a stage actress who segued into film and was nominated for Academy Awards for her parts in *Death of a Salesman* (1951) and *Baby Doll* (1956).

Patrick Gregory (1945–2014), teacher, town moderator, local businessman and family man, is buried in the Lambert's Cove Cemetery.

Other cemeteries in town include the Mingo graves on Dancing Hill Road in Christiantown, beyond Wampeche Road. Four people are buried there: Joseph Mingo (1825–1912), Lydia Mingo (1837–1914), Lucina (Jeffers) Mingo (1862–1891) and Parthenia Mingo (1862–1898).

The majority of stones in the Christiantown cemetery are unmarked head and footstones and belong to the Wampanoag tribe of Gay Head/Aquinnah. No inscription indicates who is interred. This process of burying the dead arose during the Christianizing of the Native Americans, so the graves are less than four hundred years old.

One gravestone is inscribed, that of Mary Spencer, wife of John Spencer, who died in 1847. They had three children; he was listed as "colored" in the 1850 Tisbury Vital Records.

North Tisbury Burial Ground, also known as the Middletown Cemetery, on Rogers Path (by the historic oak), hosts ninety-four graves. It was founded in 1809, and the graves date from the nineteenth century with no interment since 1960. Years ago, Roger's Path was a prominent roadway, and a church stood in the lot by the Glassworks barn, on State Road.

CHILMARK

Native American graves are marked by nondescript head and footstones and generally face the rising sun in the east, allowing souls of the dead to pass into the spirit world. "The use of a head and footstone for the marking of graves is the direct result of the introduction of Christianity to the Island since there is no known prehistoric use of grave markers of this type by Indians in the Northeastern United States."[187] The Wampanoag were "interred in a sitting position, facing east. It also seems likely that the marker stones were placed just above the head."

The Native American Graves Protection and Repatriation Act (NAGPRA) restricts destruction or looting of Native Americans graves. In 1990, Congress passed NAGPRA to ensure that the graves of Native Americans, whether or not inscribed, are preserved. This includes their funerary, cultural and sacred objects, as well as human remains.

Three Christian Indian cemeteries lie in Chilmark, including one that historian Charles Banks stated "is perhaps the oldest and best preserved Indian burial ground in New England." The site offered an impressive view of the ocean, although it is overgrown in the century since Banks described it. A second cemetery is nestled in a valley meadow near the Tiasquam River, with a fence to protect the five graves. Another site, in the vicinity of Roaring Brook, has fewer than a dozen graves.

Small, private cemeteries are scattered through Chilmark, one off Quitsa Lane and another off Putnam Road, where Dr. Charles Putnam's wife, Angelica; their infant daughter; and two of his adopted sons are buried. The Peters family has a fenced lot in a field near the Tiasquam, on Middle Road, and unmarked graves of shipwrecked sailors lie behind a house on North Road, according to local lore.

The oldest cemetery on the Vineyard is Abel's Hill, or Chilmark Cemetery, named for the Native American Abel Wauwompuhque, who died in 1713. A plaque in recognition of Abel stands by the entrance to the Cemetery.

Abel's Hill has 275 interments. Two of the oldest burials belong to Benjamin Skiffe and Benjamin Mayhew, both of whom died in 1717. Abigail Smith passed away in 1718. According to Chilmark Cemetery commissioner John Flender, "There are, however, several graves marked with a single unmarked field stone, which may be older."

Abel's Hill is the final resting place of several prominent people. The Little Women of Chilmark, Lucy and Sarah Adams, are buried on Abel's Hill. Neither attained four feet in height. They performed in the Barnum & Bailey Circus with General Tom Thumb and then retired and gained prominence teaching Sunday school across New England. Later, they opened their Chilmark house at Nab's Corner as a teahouse, serving chocolates and ices; Lucy sang gospel songs while Sarah played the organ. Sarah died in 1938 and Lucy in 1954. They are buried on the north side of Abel's Hill Cemetery.

Playwright Lillian Hellman is buried there. Though she grew up in New Orleans, she summered on the Vineyard and wrote one of her better-known plays, *Toys in the Attic*, in her Vineyard Haven attic office. She was at once a literary celebrity and a character in her own right. Her stone is modest, on the right as one enters the cemetery.

John Belushi (1949–1982), son of Albanian immigrants, commands a prominent site, denoted by a split-rail fence and two stones, often adorned with a beer can or two.

John Belushi bought property on the Vineyard in the 1970s. He said, "The Vineyard is the only place I can get a good night's sleep." *Photo by Joyce Dresser.*

The Belushi grave attracts a legion of fans more than thirty years after his 1982 death. Even on the coldest winter days, someone will stop by the grave to pay respect to this comedian who gained fame on *Saturday Night Live*, in *Animal House* and as one of the Blues Brothers. "After fans repeatedly littered the area around Belushi's grave, funeral workers at the Martha's Vineyard, Mass., cemetery where he's buried moved Belushi's body at his wife's request to an unmarked plot some distance away from the tombstone. Now the *Saturday Night Live* funnyman can rest in peace."[188] He sleeps forever on Abel's Hill.

Commissioner Flender adds other notables buried at Abel's Hill. Dr. Emily Blackwell (1826–1910) was a medical educator and one of the first female physicians in America, and Jerome Weisner (1915–1994) chaired President Kennedy's Science Advisory Committee. Another name, perhaps less prominent, is Louis Cowan (1910–1976), television and radio star who produced the *64 Thousand Dollar Question* but was caught up in the television game show scandals of the 1950s.

The most prominent memorial at the Chilmark Cemetery belongs to Rodney Dutcher. Dutcher was nationally recognized as a journalist in the New Deal era who vacationed on the Vineyard. When the hurricane of 1938 decimated Menemsha Harbor, Dutcher publicly advocated for funds to rebuild the harbor. His efforts were realized with Dutcher Dock, a pier that runs from the Menemsha Gas Station to the breakwater for the yachts of summer visitors.

Casey Reagan, who knows her way around the forgotten graveyards of Martha's Vineyard, shares that artist "Thomas Hart Benton buried his dog and had a headstone made; it's in the backyard of his former house."[189]

AQUINNAH

The Aquinnah town cemetery off Rose Meadow Way envelops a rolling hill and a field, a remote and pristine parcel, memorable for its solitude and the solemn recognition of those who have passed on. Numerous head and footstones spread across the hillside while carved tombstones lie at the lower level. This secluded cemetery is one of the most pleasant, with an expansive landscape and a windswept sense of isolation, far from the rest of the world. It presents a peaceful panorama.

The grave of Wampanoag Silas Paul (1738–1787) lies off State Road. According to Banks, "His gravestone is one of the few remaining stones

Both inscribed and Native American stones on a rolling hillside imbue this Aquinnah cemetery with a sense of peace. *Photo by Joyce Dresser.*

marking the burial places of Indians on Gay Head. He was the only Baptist minister on the Vineyard during his ministry."[190]

The Gay Head Community Church Cemetery is on tribal land, along Old South Road. Only a few inscribed stones are evident; the majority of the cemetery is made up of simple head and footstones belonging to Native Americans from years gone by.

WAR MEMORIALS

Among the more memorable commemorations of the deceased are monuments erected to honor soldiers who served our country. Memorials to the soldiers who fought in the Civil War are imposing. Enoch Cornell raised money for the Edgartown Obelisk to honor veterans of the Civil War. The Soldiers' Memorial Fountain in Oak Bluffs evidenced Charles Strahan's attempt to heal the wounds of that war.

World War II involved the most veterans. Each town recognized the men and women who went to war. Special acknowledgement was given those

who lost their lives fighting for our country.

Some 677 men and women from Martha's Vineyard served in World War II. Of those, 14 died in combat. Two monuments for soldiers who served in World War II, Korea and Vietnam sit proudly in front of the Dukes County Courthouse, in Edgartown; 209 soldiers' names are listed. Oak Bluffs has a two-sided monument on the edge of Ocean Park—one for veterans of World War I, the other side for World War II—with 138 names.

The Vineyard Haven memorial, with 269 names, is located near the entrance to the Oak Grove cemetery. West Tisbury placed its memorial, with 27 names, on the grounds of the town hall. In Chilmark, a plaque bears 26 names on a great stone in Beetlebung Corner by town hall. And in Aquinnah, the monument at the town hall has 10 names. Another plaque in front of the old town hall recognizes the high percent of volunteers from Gay Head in World War I. In a statewide competition, Gay Head sent more men to war, in relation to population, than any other town in the commonwealth.

The obelisk in Memorial (Cannonball) Park honors seventy Edgartown veterans who fought in the Civil War. The monument was unveiled on July 4, 1901. *Photo by Joyce Dresser.*

And then we have graves on the islands off the Vineyard.

The cemetery on Cuttyhunk has 142 graves.

Penikese Island Cemetery contains fourteen graves of patients in the Penikese Island Hospital who died from leprosy. The hospital operated from 1905 to 1921. Dr. Frank Henry Parker was superintendent of the hospital from 1907 until it closed. He and his wife, Marion, enhanced the lives of their patients. A plaque by the cemetery acknowledges their work

and the fourteen patients who died there. The Cuttyhunk Historical Society maintains the cemetery.

On Naushon, author/editor Paul Schneider noted the graves of Judith and Joseph Game at Tarpaulin Cove. She died in 1811, and a weeping willow adorns her gravestone. His initials are scrawled on a nearby stone.

Then there is Noman's Land, the one-hundred-acre island off Aquinnah. "The old Luce Cemetery on the shore of Noman's Land is at risk of being washed into the sea," wrote Alex Elvin of the *Gazette*.[191] An official from the Fish and Wildlife Service noted that the cemetery was literally eroding away.

The one extant gravestone on Noman's Land is that of Thomas Luce, who died in 1862. "Records at the *Gazette* show that Mr. Luce's father, Israel Luce, who died in 1797, is also buried on the small island that lies three miles south of Squibnocket."[192] Bertrand Wood, who lived on Noman's Land and whose great-grandfather was Israel Luce, reported several bodies of seamen from the elusive rumrunner *John Dwight* had drifted ashore and were buried in the cemetery.

Buddy Vanderhoop, a member of the Wampanoag tribe of Gay Head (Aquinnah) and owner of Tomahawk Charters, said, "Several graves were marked with both head and foot stones, indicating a Native American burial ground."

The *Vineyard Gazette* of September 23, 1949, fretted over the fate of the graveyard:

Here was, and perhaps still is, a burying ground on Noman's Land. There are probably few people who know of this and fewer still who know where it is. It is even more probable that no one living today knows how many graves there may be in this desolate plot, or who could mention more than two or three names of the people who lie buried there. The burying ground is or was there, containing the bones of people who made their homes on the island, very probably certain Indians, and the bodies of victims of shipwreck in days of long ago.

The lost souls of Noman's may be finally at rest.[193]

EPILOGUE

The wealth of historical data on Martha's Vineyard cries out to be shared. With this *Hidden History of Martha's Vineyard*, we have glimpsed the tip of the iceberg with the realization that there is much more below the surface, concealed in the archives of the *Vineyard Gazette*, the Martha's Vineyard Museum, local histories and the recollections of our fellow citizens.

The island has myriad moments worth remembering, savoring and treasuring. We don't know everything about a given topic, yet leafing through the pages of history allows us to grasp the unique character and background of this island we know and love.

Our lives are often so hurried and harried that we cannot and do not take the time to relish the past. We should acknowledge the memories of our senior citizens and research the words of those who came before us. Those memories and experiences inform our lives. *Hidden History of Martha's Vineyard* is intended to inspire new research, more reading, deeper discussion and further analysis of historical events.

Whether it is unique Vineyard names, fugitives struggling for freedom, daring seaside rescues, impressive buildings or solemn cemeteries, it is for us to acknowledge, appreciate and assimilate each to fully celebrate our past, prepare for the future and savor the present.

Hidden History of Martha's Vineyard offers a glimpse of the past to serve as a steppingstone for further research. Now it's up to you, dear reader, to pursue this adventure, to explore the archives cubby-holed in the museum and to

answer the questions, study the stories and understand who we are. Only if we probe our past can we protect our present and preserve our future. We brought you this far; now it's up to you to carry on.

NOTES

CHAPTER 1

1. *Vineyard Gazette*, February 24, 1928, reprinted February 26, 2016.
2. Banks, *History of Martha's Vineyard*, 2:9.
3. Ibid., 2:24.
4. Thomas Dresser, *Vineyard Gazette*, March 18, 2010.
5. Banks, *History of Martha's Vineyard*, 2:17.
6. Ibid., 2:13.
7. Ibid., 2:17.
8. Ibid.
9. Ibid., 2:13.
10. In the Winter 2016 *Dukes County Intelligencer*, Elizabeth Trotter revealed the sworn testimony of Polly Daggett in her appeal for a congressional pension in 1839. The Liberty Pole incident is described in captivating detail.
11. Tony Widmer, "The Indelible Symbolism of a Tree," *Boston Globe*, December 6, 2015.
12. *Vineyard Gazette*, April 18, 1851.
13. Ibid., July 7, 1854.
14. Ibid., September 19, 1856.
15. Ibid., January 2, 1857.
16. Jean Cargill, "Early Island Education and Leavitt Thaxter," Finding Aid to the Martha's Vineyard Museum, http://www.mvmuseum.org/collections/fa_pdfs/RU%2092--Early%20Island%20Education%20and%20Leavitt%20Thaxter.pdf.

17. Olivia Hull, "Commission Takes Steps to Protect Historic West Tisbury Roads," *Vineyard Gazette*, February 23, 2015.
18. Dresser, *Women of Martha's Vineyard*, 126.
19. Douglas Hakey, conversation with the author, February 4, 2016.

CHAPTER 2

20. Kittredge, *Cape Cod*, 63.
21. Warren Doty, interview with the author, September 30, 2015.
22. Ibid.
23. Blockson, *Underground Railroad*, 12.
24. Kathryn Schulz, "Derailed: The Troubling Allure of the Underground Railroad," *New Yorker*, August 22, 2016.
25. Foner, *Gateway to Freedom*, 22.
26. Ibid., 332–33.
27. Ibid., 349.
28. Dresser, *Music on Martha's Vineyard*, 17.
29. Ibid.
30. Foner, *Gateway to Freedom*, 25.
31. *Cape Cod Times*, February 25, 2001, updated January 5, 2011.
32. Ibid.
33. Foner, *Gateway to Freedom*, 25.
34. Ibid., 276.
35. Ibid., 40.
36. Schulz, "Derailed."
37. Foner, *Gateway to Freedom*, 59.
38. Ibid., 48.
39. Ibid., 238.
40. Ibid., 304
41. Ibid., 197.
42. Dresser, *African Americans of Martha's Vineyard*, 43–44.
43. Foner, *Gateway to Freedom*, 281.
44. *Vineyard Gazette*, October 20, 1854.
45. Ibid., March 2, 1855.
46. Ibid., December 15, 1854.
47. Ibid., June 2, 1854.
48. Ibid., June 6, 1856.
49. Ibid., March 14, 1856.

50. Ibid., November 27, 1857.

51. Ibid., September 22, 1854.

52. Captain Charles Vanderhoop Jr., interview by Linsey Lee, 2000, in Lee, *More Vineyard Voices*, 114, as reported in Dresser, *African Americans*, 34.

53. Douglass, *Life and Times of Frederick Douglass*, 34.

54. Ibid., 41.

55. Ibid., 84.

56. Ibid.

57. *Vineyard Gazette*, December 4, 1857.

58. *Cape Cod Times*, January 5, 2011.

59. Ibid.

60. Ibid.

61. *Examiner*, January 14, 2010.

62. Ibid.

63. Nadler, *Haunted Island*, 21.

64. Schulz, "Derailed."

Chapter 3

65. Scoville, *Shipwrecks on Martha's Vineyard*, 1.

66. Ibid., 6.

67. Interestingly, both the Cape Cod Canal and the Panama Canal opened in 1914.

68. Scoville, *Shipwrecks on Martha's Vineyard*, 9.

69. Ibid., 11.

70. Ibid., 18.

71. Chris Baer, "This Was Then: Detour," *Martha's Vineyard Times*, November 19, 2014.

72. *Vineyard Gazette*, December 1, 1898.

73. Ibid.

74. Ferris, *Cape Cod's Anthology of Shipwrecks*, 523.

75. Mark Lovewell, "A Century Later, Epic Sea Rescue Is Remembered," *Vineyard Gazette*, January 21, 2010.

76. *Martha's Vineyard Times*, September 14, 2011.

77. Ibid.

78. Scoville, *Shipwrecks on Martha's Vineyard*, 26.

79. Lovewell, "Century Later, Epic Sea Rescue Is Remembered."

80. *Vineyard Gazette*, February 3, 1910.

81. *Vineyard Gazette,* January 29, 1960.

82. Scoville, *Shipwrecks on Martha's Vineyard,* 28.

83. *Martha's Vineyard Times,* September 14, 2011.

84. *Vineyard Gazette,* January 29, 1960, quoted by Lovewell, "Century Later, Epic Sea Rescue Is Remembered."

85. Ibid.

86. Ibid.

87. *Vineyard Gazette,* November 14, 1918.

88. Scoville, *Shipwrecks on Martha's Vineyard,* 31.

89. Stan Lair, recollection recorded 1979, transcribed by Chris Baer, 1995, http://history.vineyard.net/history.htm.

90. In a nod to historical relevance, two restaurants face each other across Main Street in Edgartown. The Port Hunter and the Covington both provide delightful dining experiences to locals and tourists alike.

91. The first Barney Zeitz, who died in 1946, was the namesake of the second. Local artisan Zeitz says of his great-uncle, whom he never knew, "I guess he was quite a character."

92. Stan Lair, recollection recorded 1979, transcribed by Chris Baer, 1995, http://history.vineyard.net/history.htm.

93. District Court, D. Massachusetts 6 F Supp. 1009 (1934), the *Port Hunter* No. 562, May 10, 1934.

94. Ibid.

95. Sam Low, "Port Hunter, Ghost Ship Sixty Feet Beneath Tides Is Visited in Exciting Venture of Young Divers," *Vineyard Gazette,* August 19, 1960.

96. Ibid.

97. Ibid.

98. Scoville, *Shipwrecks on Martha's Vineyard,* 38.

99. Ibid.

100. *Vineyard Gazette,* April 12, 1923.

101. Ibid., April 26, 1923.

102. Ibid., May 31, 1923.

103. Chris Hugo, e-mail communication with the author, December 23, 2015.

104. Christine Migala, e-mail communication with the author, December 28, 2015.

105. Bill McGrath, e-mail communication with the author, April 29, 2016.

106. Arne Carr, e-mail communication with the author, March 2, 2016.

107. Jimmy Morgan, conversation with the author, March 4, 2016.

CHAPTER 4

108. Meras, *Country Editor*, 81.

109. Ibid.

110. Martha's Vineyard Museum files, http://www.mvmuseum.org/collections/EAD_FindingAids/findingaid_get.php?record-unit=RU463.

111. Waterway, *Gay Head Lighthouse*, 38.

112. Alex Elvin, "Iconic Harbor View Hotel Parallels History of Edgartown," *Vineyard Gazette*, July 10, 2014.

113. Ibid.

114. Ibid.

115. Ibid.

116. *Martha's Vineyard Times*, August 25, 2014.

117. Ibid.

118. Ibid.

119. Interestingly, the carousel at Watch Hill is called the Flying Horse, and the horses are suspended by chains rather than attached to the base. The Flying Horse was built the same year as the Oak Bluffs carousel, 1876, and arrived at Watch Hill in 1883.

120. Arthur Levine, "Flying Horses Carousel: Antique Carousel at Oak Bluffs on Martha's Vineyard," About Travel, http://themeparks.about.com/od/carousels/a/FlyingHorsesMV.htm.

121. Tom Dunlop, "Uniting the Divided," *Martha's Vineyard Magazine*, August 1, 2013.

122. The Civil War statue in North Kingston was purchased by the Grand Army of the Republic, veterans of the Union army. It came from the same company as the Oak Bluffs statue and was installed in 1912 adjacent to the train station. When the station was demolished in the 1930s, the statue was relocated in front of town hall.

123. Dunlop, "Uniting the Divided."

124. Joshua Sabatini, "Oak Bluffs Civil War Statue Rededicated," *Vineyard Gazette*, August 20, 2001.

125. Dunlop, "Uniting the Divided."

126. Sabatini, "Oak Bluffs Civil War Statue Rededicated."

127. Ibid.

128. Jim Hickey, "Denniston House Once Served as Spiritual, Educational Center," *Vineyard Gazette*, March 27, 2008.

129. Ibid.

130. Banks, *History of Martha's Vineyard*, 2:56.

131. The cupola deck has a Web cam. Susan Goldstein says, "When there is a strong wind, the camera gets turned around. In a few days, the e-mails come flooding in from around the world by Vineyard visitors who need their island views. We have received e-mails from viewers in Ghana, Serbia, Chile, Australia, Hawaii, Spain and France reminding us to fix the Web cam!"

132. John Budris, "Utility Player the Pantry Makes a Common-Sense Comeback as the Most Practical Room in the House," *Boston Globe*, October 19, 2003.

133. Susan Goldstein, e-mail communication with the author, December 9, 2013.

134. Tony Omer, "The Rebuilt Martha's Vineyard Playhouse Will Raise Its Curtain in June," *Martha's Vineyard Times*, April 16, 2014.

135. "Christ United Methodist Church," Pipe Organs of Cape Cod & the Islands, http://www.capecodpipeorgans.org/organs/vineyardhavenmethodist.html.

136. Tom Dresser, "The Vineyard Haven Band: A Chronicle From Origins in Wake of Civil War, to Beloved Island Institution," *Dukes County Intelligencer*, Spring 2010.

137. "Christ United Methodist Church."

138. Dresser, *Music on Martha's Vineyard*, 86.

139. Island Food Pantry website, http://www.islandfoodpantry.org/html/history.htm.

140. Pat Waring, "Island Ministry Provides Clothes to Go," *Martha's Vineyard Times*, April 30, 2014.

141. Brenda Piland, conversation with the author.

142. Waring, "Island Ministry Provides Clothes to Go."

143. Barney Zeitz, in an e-mail with the author, December 3, 2015.

144. The Charles Connick Studio operated in Boston's Back Bay from 1913 to 1986. The website states, "Using pure, intense color and strong linear design, this guild of artists led the modern revitalization of medieval craftsmanship in the United States."

145. "Christiantown," *MV Obsession*, June 21, 2008, http://mvobsession.com/2008/06/21/christiantown.

146. Alex Elvin, "New Efforts Are Underway to Restore Mayhew Chapel," *Vineyard Gazette*, September 4, 2014.

147. Website of the Martha's Vineyard Preservation Trust, http://mvpreservation.org.

148. Mike Seccombe, "Inside the Oldest House on the Vineyard," *Vineyard Gazette*, September 9, 2010.

149. Ibid.

150. Remy Tumin, "Three Centuries Old, Quansoo House Ready for a Makeover," *Vineyard Gazette*, September 26, 2013.

151. Alex Elvin, "Peeling Back Layers of Time at Historic Chilmark House," *Vineyard Gazette*, January 15, 2015.

152. Ibid.

153. *Vineyard Gazette*, February 5, 2015.

154. Adam Moore, telephone interview with the author, February 22, 2016.

155. Jane Slater, Chilmark town column, *Vineyard Gazette*, May 27, 2010.

156. Tom Dunlop, "The Name Behind Dutcher Dock," *Martha's Vineyard Magazine*, July 1, 2011.

157. Ibid.

158. *Martha's Vineyard Times*, April 22, 2015.

159. Website of the Wampanoag Tribe of Gay Head/Aquinnah, http://www.wampanoagtribe.net/Pages/index.

160. Ibid.

161. Dan Cabot, "Of Faith Vineyard Baptists Consider a Crossroads," *Martha's Vineyard Times*, December 21, 2011.

162. Ibid.

163. Waterway, *Gay Head Lighthouse*, 134.

164. Website of the Wampanoag Tribe of Gay Head/Aquinnah.

165. Aquinnah Library website, http://www.aquinnah-ma.gov/content/aquinnah-public-library.

166. Ibid.

167. Ivy Ash, "Bustle Lies Beyond These Small Walls," *Vineyard Gazette*, August 20, 2012.

168. Ibid.

CHAPTER 5

169. Schneider, *Enduring Shore*, 40.

170. "II. Burial Customs and Cemeteries in American History," National Register Bulletin: Guidelines for Evaluating and Registering Cemeteries and Burial Places, http://www.nps.gov/nr/publications/bulletins/nrb41/nrb41_5.htm.

171. James Richardson, "Death's Heads, Cherubs, Urn and Willow: A Stylistic Analysis of Martha's Vineyard Tombstones," *Dukes County Intelligencer*, February, 1969.

172. Ibid.

173. Ibid.

174. Ibid.

175. Ibid.

176. John Alley, conversation with the author, January 7, 2016.

177. Banks, *History of Martha's Vineyard*, 1:504.

178. Town of Edgartown, cemetery website, http://www.edgartown-ma. us/departments/cemetery.

179. Ibid.

180. Hilary Wall, Gazette Chronicle column, *Vineyard Gazette*, November 3, 1967, republished November 6, 2015.

181. Nicole Morey of Oak Bluffs, e-mail communication with the author, December 15, 2015.

182. "Crossways Cemetery," Martha's Vineyard Cemeteries, http://history. vineyard.net/cemetery/index.html.

183. Alley, conversation.

184. Banks, *History of Martha's Vineyard*, 1:502.

185. Katie Ruppel, "At Rest but Alive with Vineyard's History," *Vineyard Gazette*, October 25, 2012.

186. Joseph Elvin, "The Lambert's Cove Cemetery," *Dukes County Intelligencer*, November 1963.

187. Peter Colt Josephs, "Christian Indian Cemeteries," *Dukes County Intelligencer*, February 1983.

188. "Top 10 Celebrity Grave Sites," *TIME*, http://content.time.com/time/specials/packages/article/0,28804,1919236_1919237_1919234,00.html.

189. Casey Reagan, e-mail communication with the author, August 25, 2016.

190. Banks, *History of Martha's Vineyard*, 2:23.

191. Alex Elvin, "Erosion at Noman's Threatens Old Cemetery Near Shore," *Vineyard Gazette*, January 22, 2015.

192. Ibid.

193. Peter Brannen, "On the Ground at Noman's Land," *Martha's Vineyard Magazine*, September 1, 2011, quoting *Vineyard Gazette*, September 23, 1949.

BIBLIOGRAPHY

Banks, Charles. *The History of Martha's Vineyard*. Vols. 1–3. Edgartown, MA: Dukes County Historical Society, 1911; republished, 1966.

Blockson, Charles. *The Underground Railroad*. New York: Hippocrene Books, 1994.

District Court Case. D. Massachusetts 6 F Supp. 1009 (1934). The *Port Hunter* No. 562, May 10, 1934.

Douglass, Frederick, adapted by Barbara Ritchie. *Life and Times of Frederick Douglass*. New York: Thomas Y. Crowell Company, 1966.

Dresser, Thomas. *African Americans of Martha's Vineyard*. Charleston, SC: The History Press, 2010.

———. *Disaster off Martha's Vineyard*. Charleston, SC: The History Press, 2012.

———. *Music on Martha's Vineyard*. Charleston, SC: The History Press, 2014.

———. *Women of Martha's Vineyard*. Charleston, SC: The History Press, 2013.

Ferris, Donald. *Cape Cod's Anthology of Shipwrecks*. East Sandwich, MA: DLF Publishing, 2009.

Foner, Eric. *Gateway to Freedom: The Hidden History of the Underground Railroad*. New York: W.W. Norton & Company, 2015.

Hall, Stacy, and Jannette Vanderhoop. *The Legend of Katama*. Cranston, RI: Writer's Collective, 2004.

Kittridge, Henry. *Cape Cod: Its People and Their Story*. Hyannis, MA: Parnassus Imprints, 1930; republished, 1968.

Lee, Linsey. *More Vineyard Voices*. Edgartown, MA: Martha's Vineyard Historical Society, 2005.

Bibliography

Meras, Phyllis. *Country Editor*. Bennington, VT: Images from the Past with the Martha's Vineyard Historical Society, now the Martha's Vineyard Museum, 2008.

Nadler, Holly. *Haunted Island*. Camden, ME: Down East Books, 1994.

Schneider, Paul. *The Enduring Shore*. New York: Henry Holt & Company, 2000.

Scoville, Dorothy. *Shipwrecks on Martha's Vineyard*. Edgartown, MA: Dukes County Historical Society, 1972.

Waterway, William Marks. *Gay Head Lighthouse*. Charleston, SC: The History Press, 2014.

Periodicals

Cape Cod Times
Dukes County Intelligencer
Examiner
Martha's Vineyard Magazine
Martha's Vineyard Times
The New Yorker
Vineyard Gazette

Index

ABOUT THE AUTHOR

At the age of eleven, Thomas Dresser started a monthly newspaper and edited the *Springdale News* until he entered Boston University and earned a degree in American history and civilization. In the Vietnam era, Dresser was a conscientious objector. For ten years, he taught elementary school at Fort Devens Army Base; for the next twenty years, he worked as a nursing home administrator in Massachusetts facilities. And following that career, Dresser drove tour buses and a school bus on Martha's Vineyard for a dozen years.

In 1995, Dresser re-met Joyce, a high school classmate, and they've been married for nearly twenty years. Joyce shares his appreciation for life on Martha's Vineyard. Together they enjoy life at the high end of middle age.

Hidden History of Martha's Vineyard is Dresser's ninth book with The History Press, all based on researching the intriguing history and unique heritage

of Martha's Vineyard. For further information, visit thomasdresser.com or explore these titles:

Mystery on the Vineyard
African Americans of Martha's Vineyard
The Wampanoag Tribe of Martha's Vineyard
Disaster Off Martha's Vineyard
Women of Martha's Vineyard
World War II on Martha's Vineyard
Music on Martha's Vineyard
Martha's Vineyard: A History